SUPER SIMPLE

Hand-Lettering

PROJECTS

SUPER SIMPLE

PROJECTS

Techniques and Craft Projects Using Hand Lettering

KILEY BENNETT

PHOTOGRAPHY BY CONNIE SHUFFETT

DESIGN ORIGINALS

an Imprint of Fox Chapel Publishing

www.d-originals.com

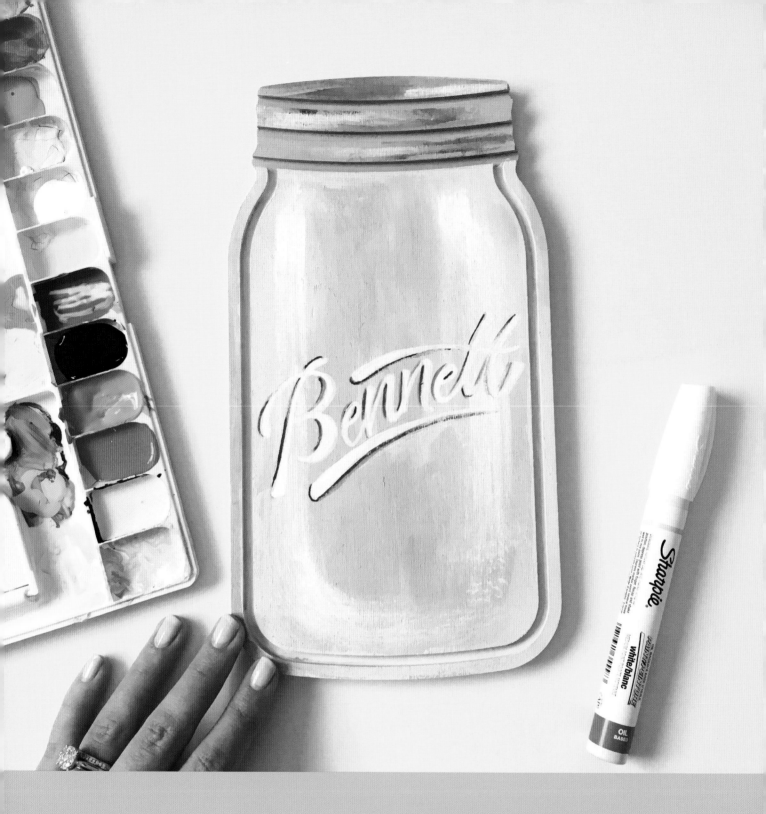

ISBN 978-1-4972-0451-5

NOTE TO PROFESSIONAL COPY SERVICES: The publisher grants you permission to make up to six copies for any purchaser of this book who states the copies are for personal use.

WARNING: Due to the components used in this craft, children under 8 years of age should not have access to materials or supplies without adult supervision. Under rare circumstances components of products could cause serious or fatal injury. Please read all safety warnings for the products being used. Neither New Design Originals, the product manufacturer, or the supplier is responsible.

NOTE: The use of products and trademark names is for informational purposes only, with no intention of infringement upon those trademarks.

© 2020 by Kiley Bennett and New Design Originals Corporation, www.d-originals.com, an imprint of Fox Chapel Publishing, 800-457-9112, 903 Square Street, Mount Joy, PA 17552.

Photography by Connie Shuffett Photography, @connieshuffettphotography

Library of Congress Control Number:2019956338

We are always looking for talented authors. To submit an idea, please send a brief inquiry to acquisitions@foxchapelpublishing.com.

Printed in Singapore
First printing

About THE Author

Kiley Bennett is the artist and teacher behind Kiley in Kentucky (*www.kileyinkentucky.com*). In 2015, Kiley purchased a couple of brush pens on her lunch break and then spent the rest of the day lettering at her desk at work. Within a year, she was able to take her new business as a lettering artist full-time, and she has since begun teaching online classes to students from around the world! Since the release of her first book, *Super Simple Hand Lettering*, Kiley has expanded her focus to include art in other mediums, with brush lettering still being the one she knows best. Kiley and her husband, Daniel, live in Lexington, Kentucky.

Contents

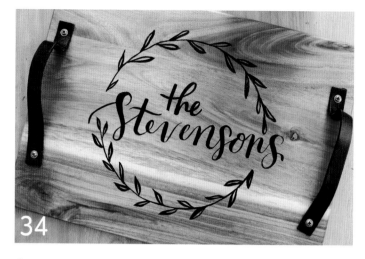

34

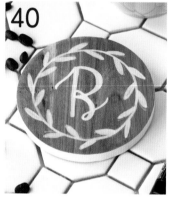

40

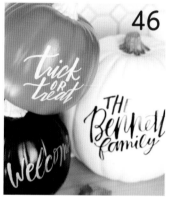

46

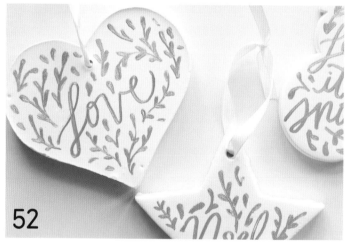

52

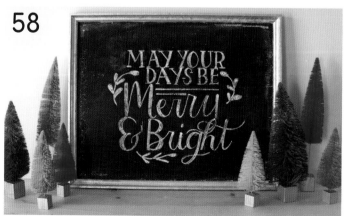

58

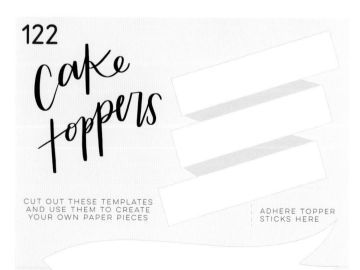

122

cake toppers

CUT OUT THESE TEMPLATES AND USE THEM TO CREATE YOUR OWN PAPER PIECES

ADHERE TOPPER STICKS HERE

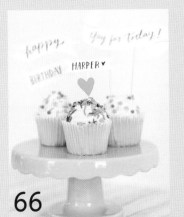

66

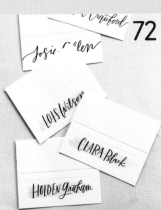

72

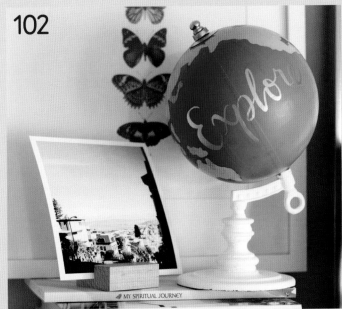

102

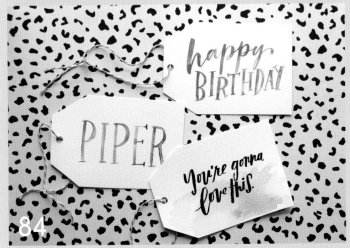

78

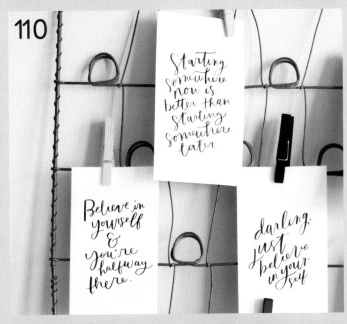

110

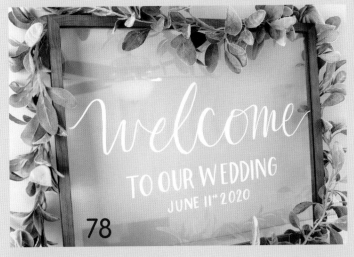

84

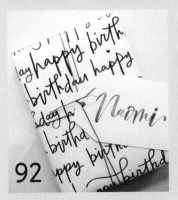

92

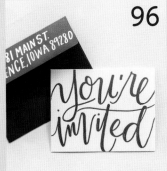

96

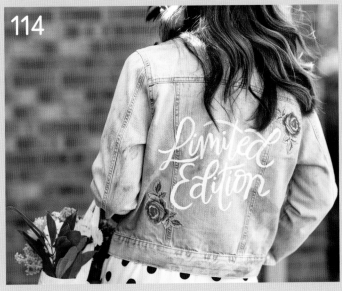

114

You're gonna love this.

Hello, Artist

I am honored that you have chosen this book to inspire creativity in your life. Whether you've been lettering for years, months, weeks, or days, please know that your art will bring joy and beauty into the world however you choose to share it—and I really hope you choose to share it!

In this book, you'll find super simple projects for the home, holidays, celebrations, and beyond. My biggest hope is that you will use this book to light your own spark of creativity—these projects are customizable in countless ways. Your own personal touch is the only step I couldn't include inside these pages.

Now, get to making and share your gifts with the world!

Best wishes and happiest lettering,

Kiley

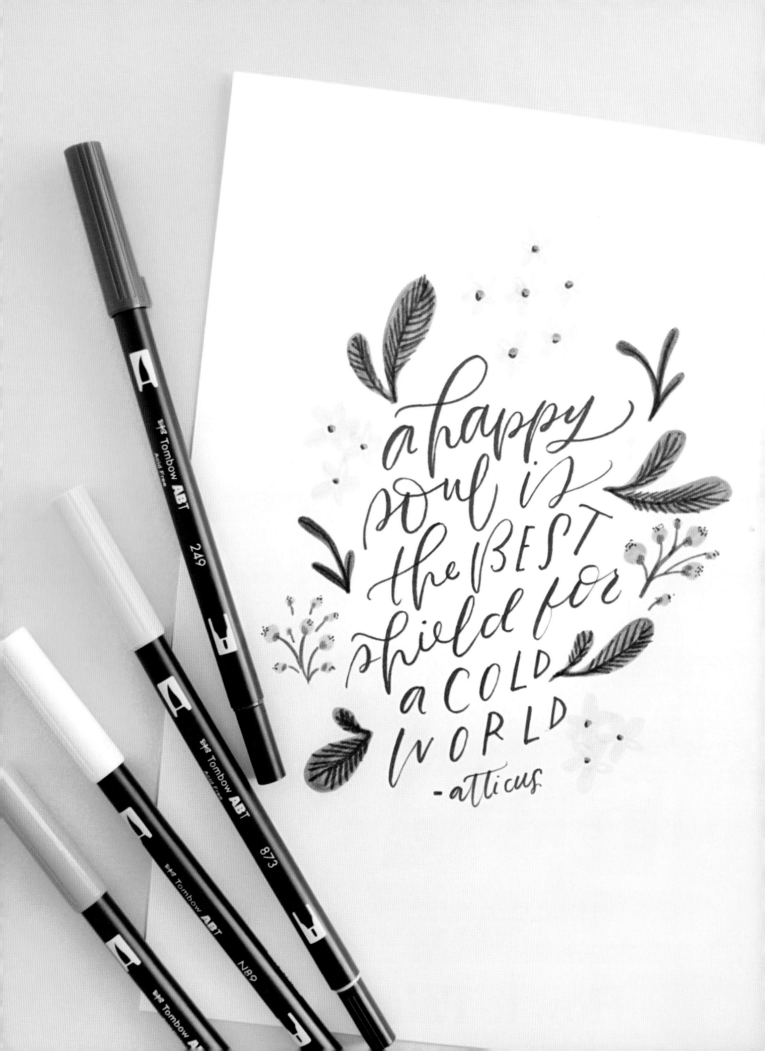

a happy
soul is
the BEST
shield for
a COLD
WORLD
-atticus

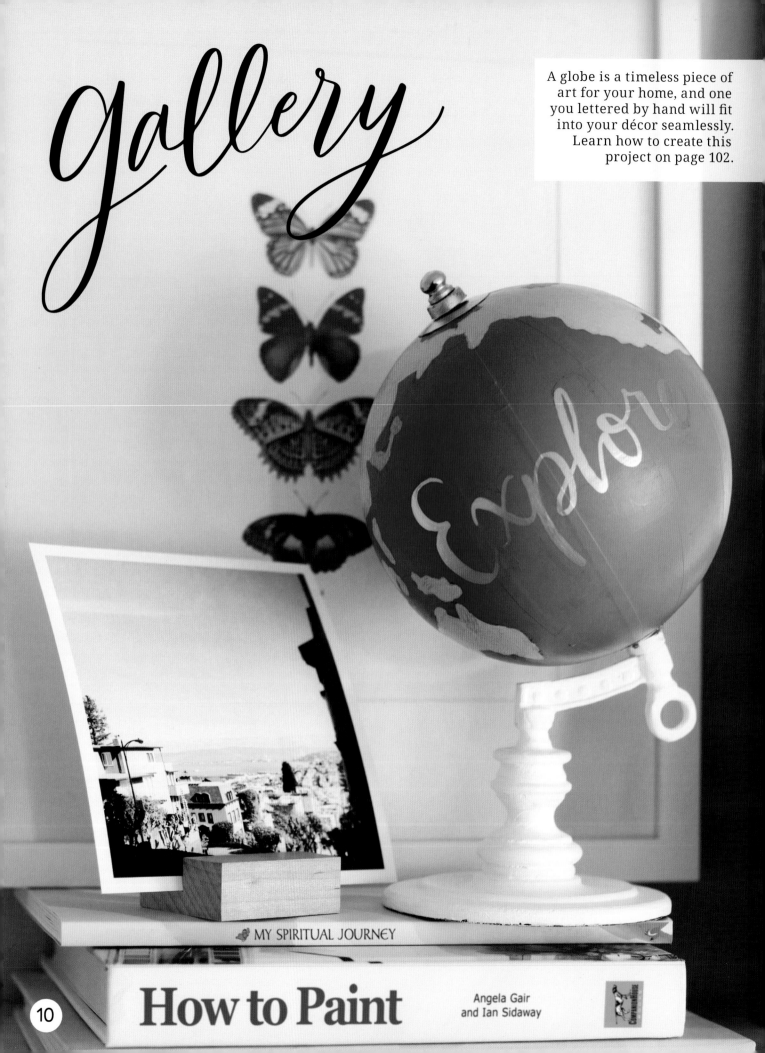

Gallery

A globe is a timeless piece of art for your home, and one you lettered by hand will fit into your décor seamlessly. Learn how to create this project on page 102.

Explore

MY SPIRITUAL JOURNEY

How to Paint
Angela Gair and Ian Sidaway

10

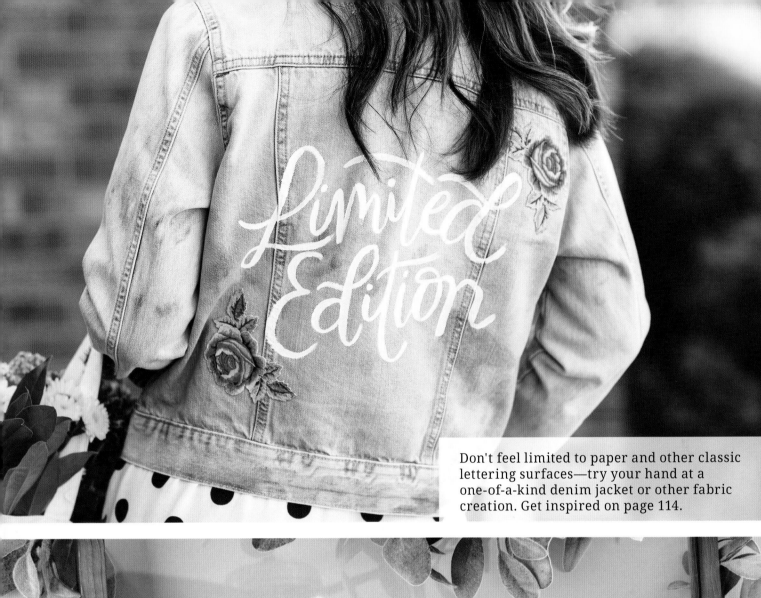

Don't feel limited to paper and other classic lettering surfaces—try your hand at a one-of-a-kind denim jacket or other fabric creation. Get inspired on page 114.

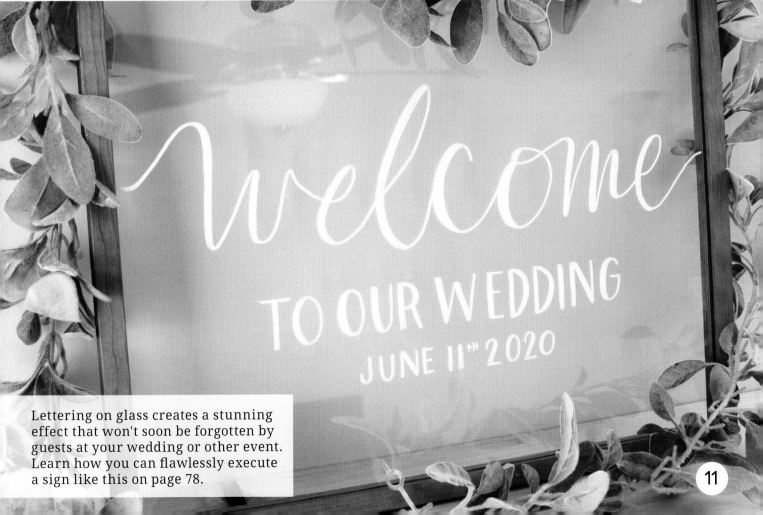

Lettering on glass creates a stunning effect that won't soon be forgotten by guests at your wedding or other event. Learn how you can flawlessly execute a sign like this on page 78.

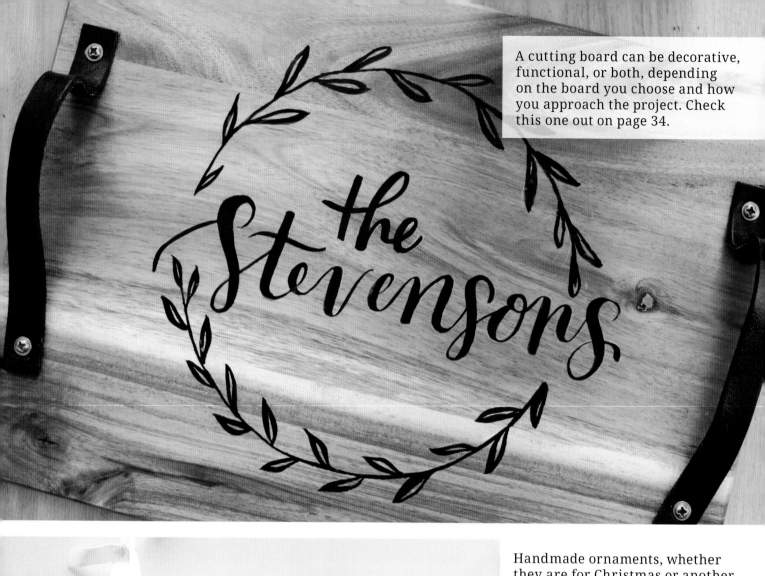

A cutting board can be decorative, functional, or both, depending on the board you choose and how you approach the project. Check this one out on page 34.

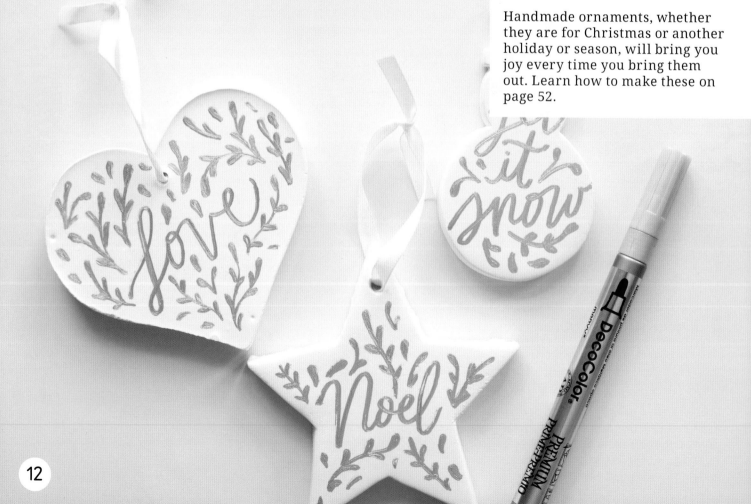

Handmade ornaments, whether they are for Christmas or another holiday or season, will bring you joy every time you bring them out. Learn how to make these on page 52.

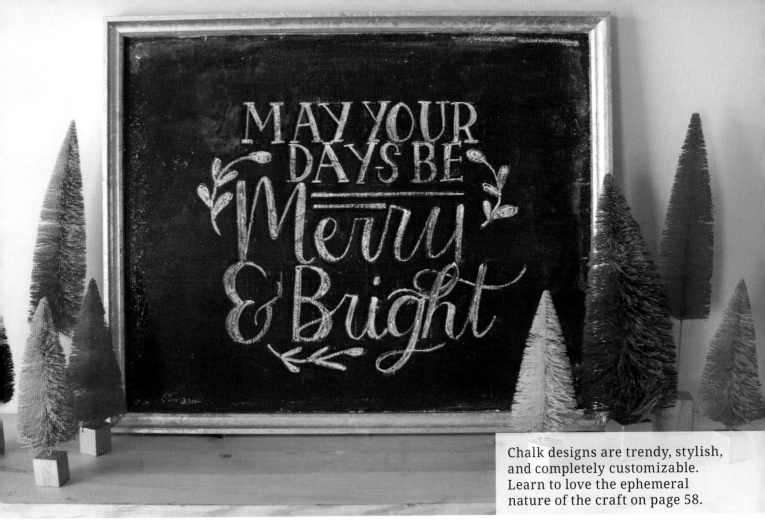

MAY YOUR DAYS BE *Merry* & *Bright*

Chalk designs are trendy, stylish, and completely customizable. Learn to love the ephemeral nature of the craft on page 58.

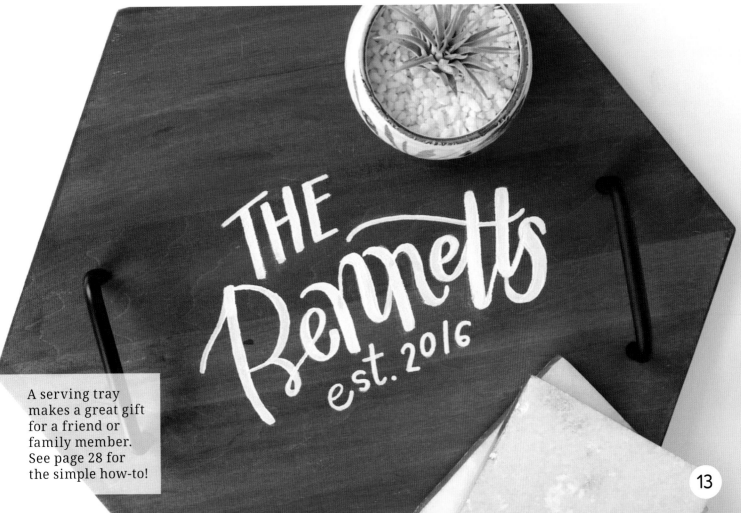

THE *Bennetts* est. 2016

A serving tray makes a great gift for a friend or family member. See page 28 for the simple how-to!

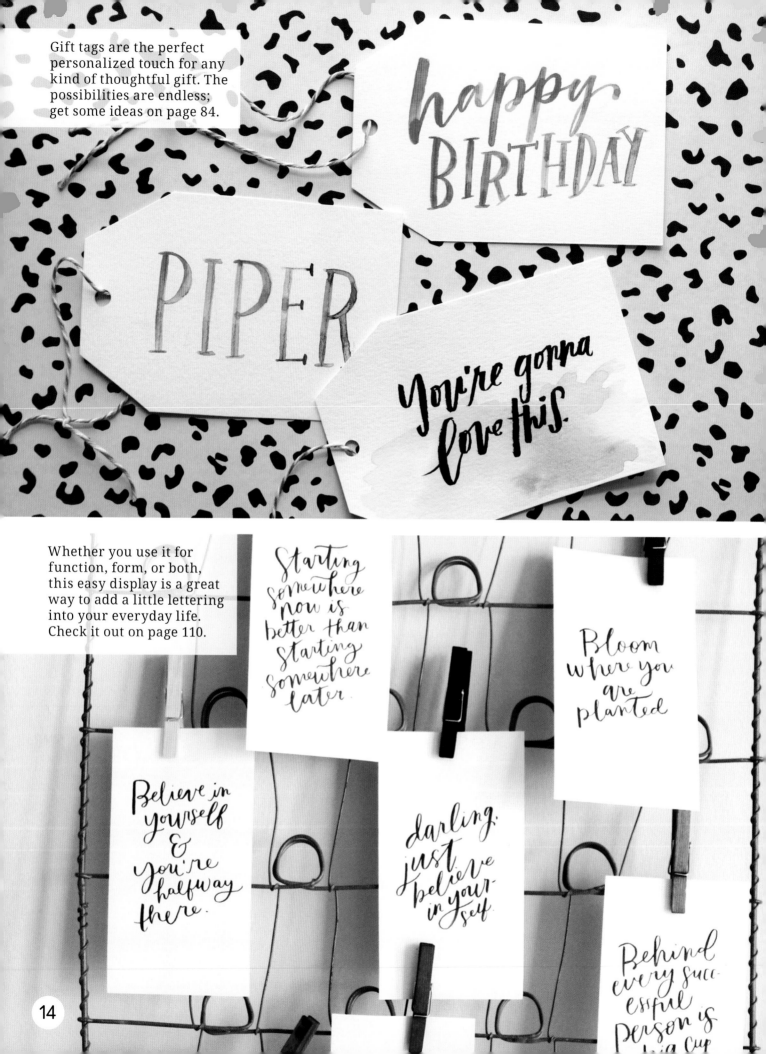

Gift tags are the perfect personalized touch for any kind of thoughtful gift. The possibilities are endless; get some ideas on page 84.

happy BIRTHDAY

PIPER

You're gonna love this.

Whether you use it for function, form, or both, this easy display is a great way to add a little lettering into your everyday life. Check it out on page 110.

Starting somewhere now is better than starting somewhere later.

Bloom where you are planted

Believe in yourself & you're halfway there.

darling, just believe in yourself.

Behind every successful person is

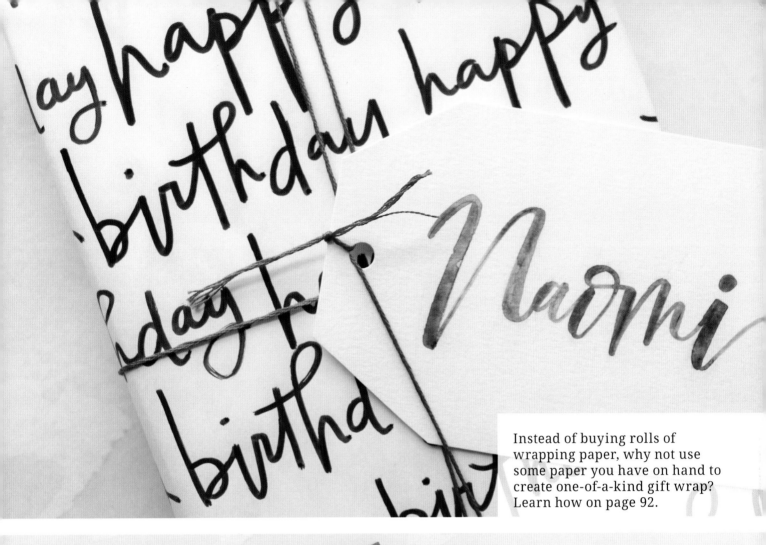

Instead of buying rolls of wrapping paper, why not use some paper you have on hand to create one-of-a-kind gift wrap? Learn how on page 92.

Corresponding by mail is fast becoming a lost art, but you can help bring it back and make an impression with these customized envelopes and cards. Get started on page 96.

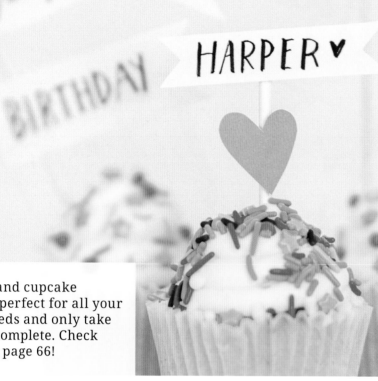

These cake and cupcake toppers are perfect for all your birthday needs and only take minutes to complete. Check them out on page 66!

Are you ready to throw a classy and memorable party? Not if you don't have a set of personalized place settings for the occasion! Learn how to make these on page 72.

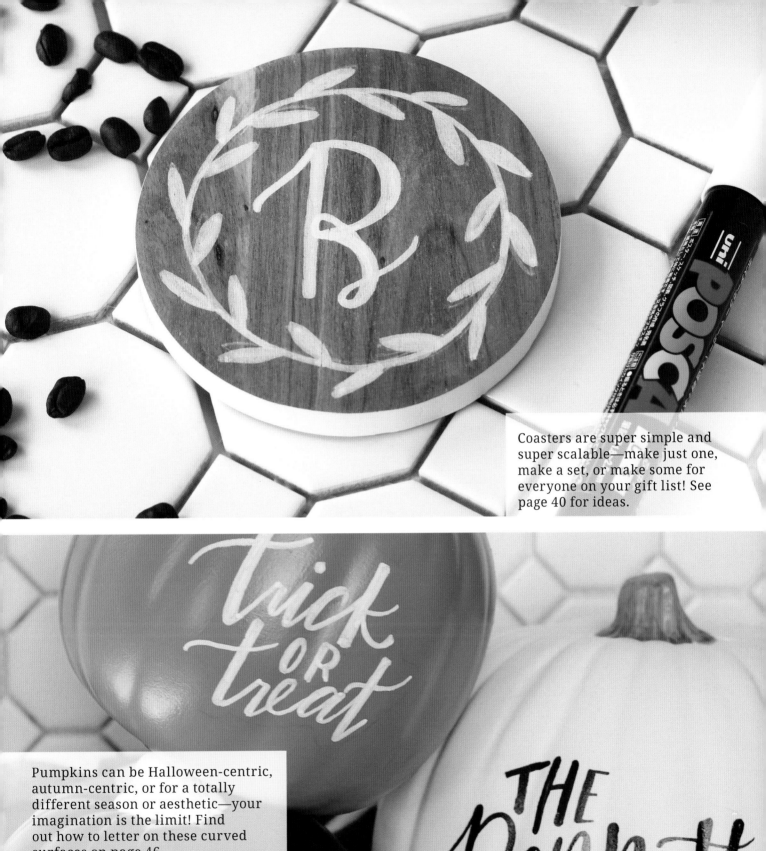

Coasters are super simple and super scalable—make just one, make a set, or make some for everyone on your gift list! See page 40 for ideas.

Pumpkins can be Halloween-centric, autumn-centric, or for a totally different season or aesthetic—your imagination is the limit! Find out how to letter on these curved surfaces on page 46.

Lettering
REFRESH

start where you are. Use what you HAVE do what you can. (Easy)

Lettering REFRESH

This book focuses on teaching you how to apply your hand-lettering skills to the "real world"—how to use them to create beautiful hand-lettered items. But if you've picked this book up and have never lettered before, fear not! We're starting out here with a little refresher course on the basics—just enough to get you going right away.

Throughout this book, you'll see the same tools and processes used across many of the projects! That's because these are the tools I am comfortable using. That's important—find what *you're* comfortable working with. The projects in this book are so versatile. If I am using a paint pen, but you'd rather work with a paintbrush, that is totally fine! The point is simply to create with confidence.

Lettering can be done in many forms. Brush lettering is the most popular, but it may not be the easiest form, depending on your skill level. If you are new to brush lettering, don't worry! The basics of this kind of lettering style are simple: a brush pen tip is tapered and flexible, which allows you to make thin upstrokes and thick downstrokes.

CHECK OUT MY FIRST BOOK FOR MORE LETTERING INSTRUCTION!

My first book, *Super Simple Hand Lettering*, includes more detailed instructions and covers layout, flourishes, and more. It also contains twenty diverse alphabets for you to practice! If you want to focus on your lettering skills and techniques, pick up a copy for yourself and use it alongside this book.

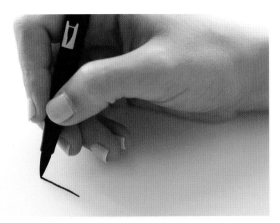

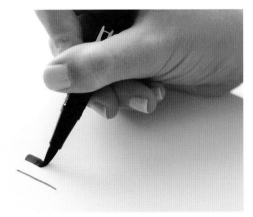

An upstroke is any time your pen moves upward or away from your body. When you make upstrokes with a brush pen, you should apply little to no pressure to the pen tip, using only the thinnest part of the pen to make the stroke. See how there is no bend in the tip of the pen in this photo?

Downstrokes are just the opposite: any time your pen moves downward, you're making a downstroke! Downstrokes should be thick, so apply considerable pressure to the flexible tip of your pen. Notice how the tip of the pen is bent in this photo?

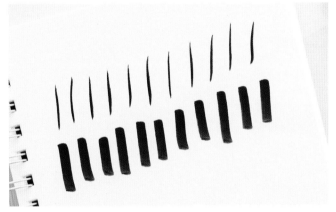

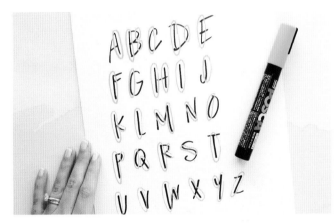

I always warm up by creating as many upstrokes and downstrokes as I need to until my hand feels a little steadier. I highly recommend this before putting your lettering on a project.

An easy exercise to do in order to get the hang of noticing where your downstrokes are is to grab a piece of paper, write the alphabet, and circle every stroke that was a downstroke.

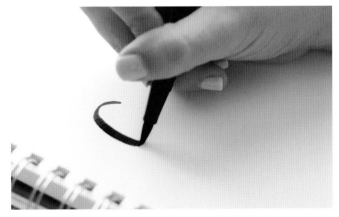

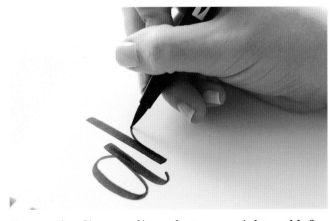

When lettering with a brush pen, you'll need to constantly change the amount of pressure you apply between strokes. See the difference between the upstroke and downstroke just in this small part of a letter? Take your time and practice as much as you need to!

Connecting lines, or lines that move right and left, should also be thin strokes.

brush lettering

Brush lettering is typically done using a brush pen, but it can also be done with a round-tip paintbrush.
These are my favorite brush pens!

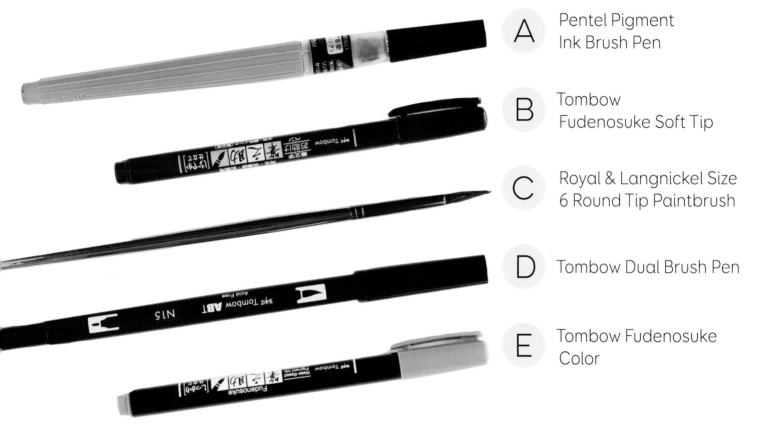

A Pentel Pigment Ink Brush Pen

B Tombow Fudenosuke Soft Tip

C Royal & Langnickel Size 6 Round Tip Paintbrush

D Tombow Dual Brush Pen

E Tombow Fudenosuke Color

Each of these tools produces a slightly different look. The size of the brush nib determines how dynamic the lettering will look. Here's an example of the thickest and thinnest strokes that each of these pens will create.

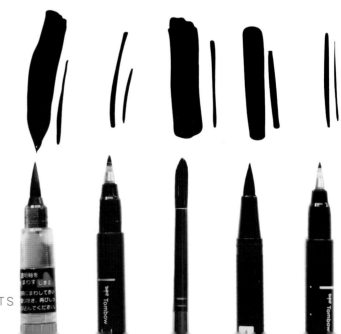

If you need a little practice, use the brush pen of your choice to practice these strokes—grab a sheet of paper to place on top of this page and trace.

LARGE BRUSH PEN WARM-UP

SMALL BRUSH PEN WARM-UP

faux calligraphy

Faux calligraphy is another great, accessible option for the non-brush pen user. Faux calligraphy can be created with any monoline pen.

Here are the monoline pens you'll see featured throughout this book; they're my favorites:

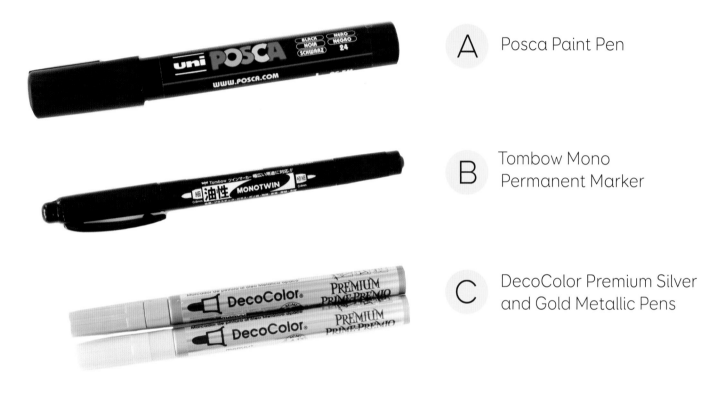

A Posca Paint Pen

B Tombow Mono Permanent Marker

C DecoColor Premium Silver and Gold Metallic Pens

A monoline pen does not have a flexible pen tip, so the pen will only create one size of stroke. As you'll see throughout this book, monoline lettering looks great without thickening your downstrokes to create calligraphy...*but* if you want a calligraphy look, you can always create faux calligraphy. You'll start with monoline lettering.

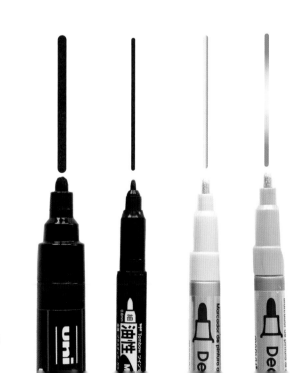

monoline lettering

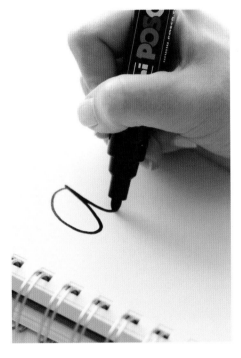

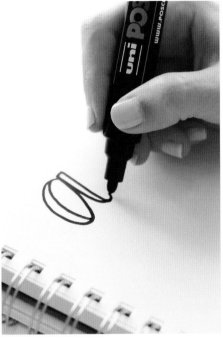

To create faux calligraphy, simply begin by drawing your letter with a monoline pen.

Add another line to the side of your downstrokes, connecting the lines so there are no breaks.

Fill in to create the look of traditional brush lettering! See how easy that is?

add Serifs

To create easy serif lettering, add notches to the ends of your letters as shown here. You can do this with uppercase and lowercase letters and with monoline or brush pens.

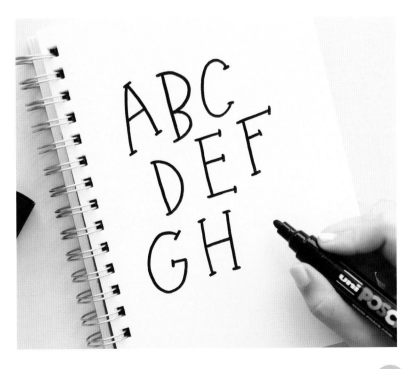

Projects

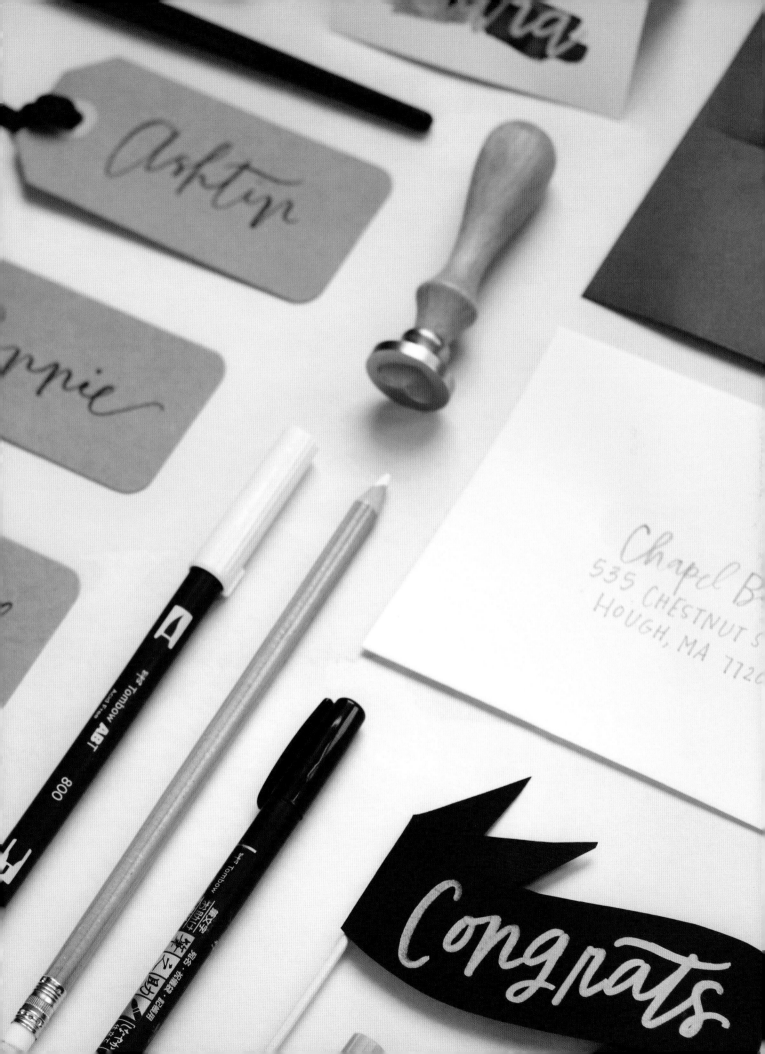

Wooden Serving Tray

A personalized wooden serving tray is a sweet addition to your kitchen, and what's even sweeter is how simple this project is! I finished off this tray with handles at the end, but you can start with a completely finished tray if you prefer. It's totally up to you!

MATERIALS

- Wooden tray
- Pencil or pastel chalk pencil
- Paintbrush
- White craft paint
- Paint palette
- Paint pen (optional)
- Eraser
- Handles (optional)
- Food-safe finishing spray (optional)

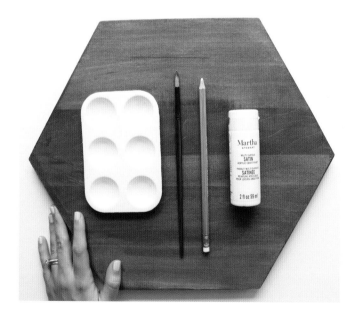
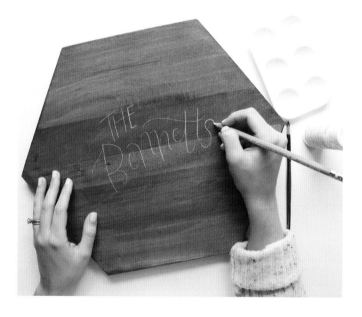

1 To get started, you'll need a pencil for sketching your design on your tray. If your wooden tray is a lighter wood, a regular graphite pencil will work great. However, I'm using a darker wood tray, so I'm using a white pastel chalk pencil, which can be found at any arts and crafts store. You'll also need a paintbrush, white craft paint, and a paint palette or tray for holding your paint.

2 Start by sketching your design. Use any phrase or name you would like. Simply sketch it out in a pretty script.

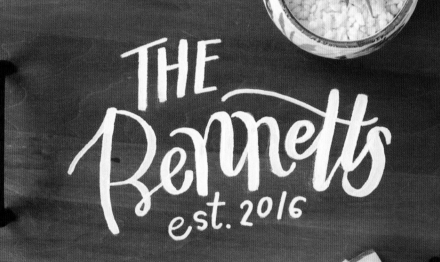

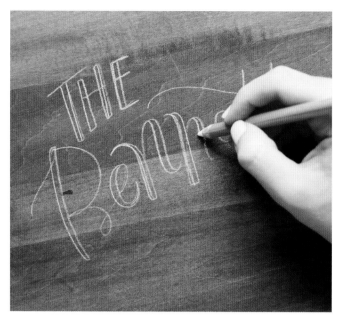

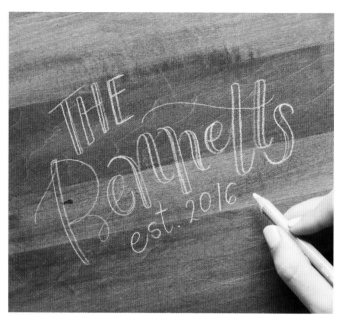

3 Go back over your sketch and add in thick downstrokes to achieve the traditional brush-lettered look.

4 I added this finishing touch to personalize my wooden tray even more. Choose the touches that make sense to you. You could add small flourishes around the lettering or a border around the edge of the entire tray.

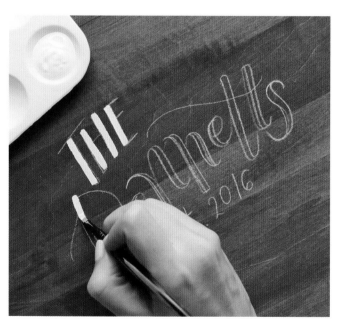

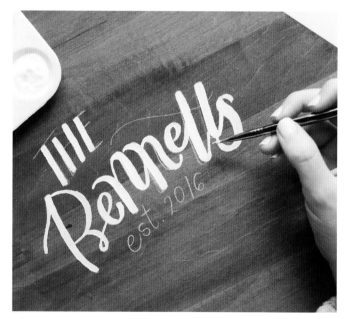

5 Begin painting. This is a round-tip paintbrush, which is the paintbrush equivalent to a brush pen. When buying paintbrushes for lettering, make sure to look for the phrase "round tip" in the description. Because using a paintbrush is trickier than using a brush pen, I like to start by filling in my thick downstrokes first.

6 When the downstrokes are complete, fill in all the other strokes with the thin, pointed tip of the brush. Go slow and take your time!

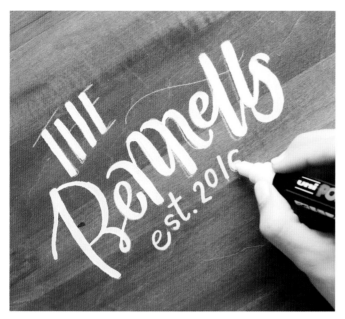

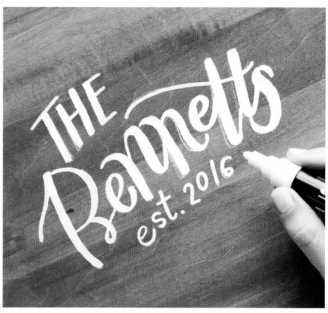

7 If you are unable to fill in the thinnest details with the paintbrush, switch over to a paint pen to finish off the design.

8 Wait until the paint is completely dry and then carefully erase any stray pencil marks. That's it—you're done!

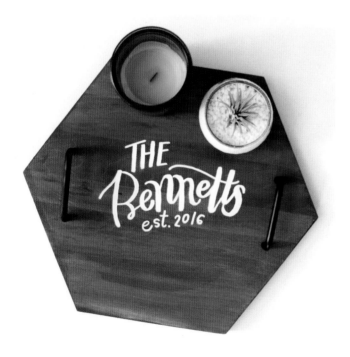

9 I finished off my tray by attaching the handles (they screwed in from the underside) and styling it up for décor in my kitchen.

TIP:
If you plan to use this serving tray for any purpose other than décor, please seal it with a food-safe sealant. The paint, as is, is not food safe!

I added thicker lettering to this serving tray to create something festive for summer gatherings. Use a thicker, flat-tip paintbrush to achieve this chunky monoline look.

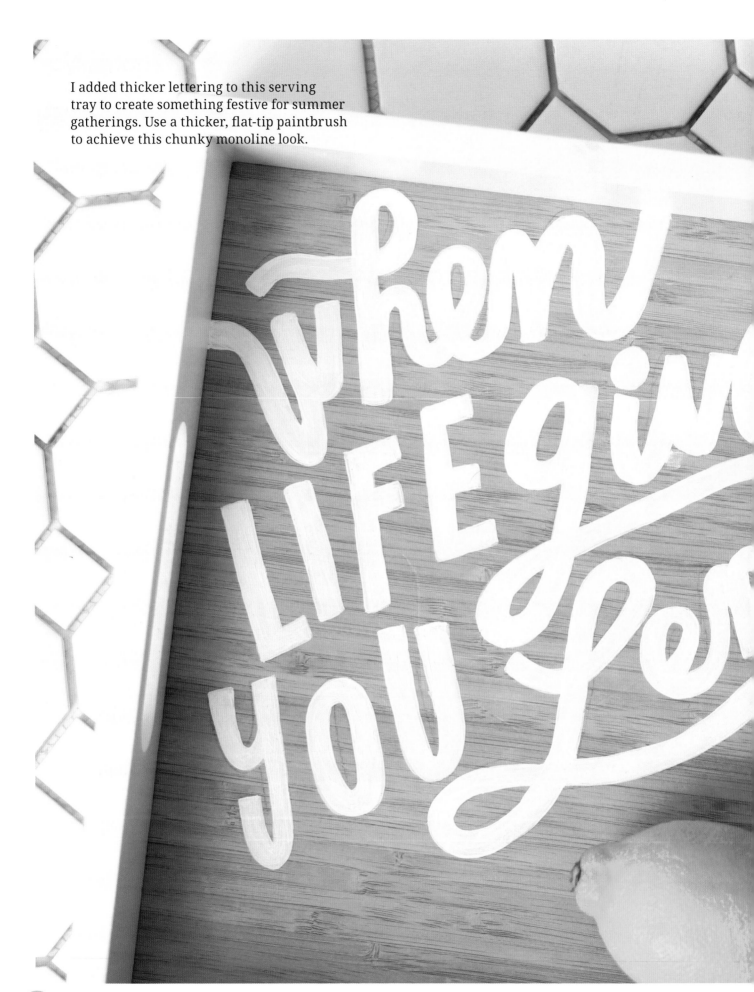

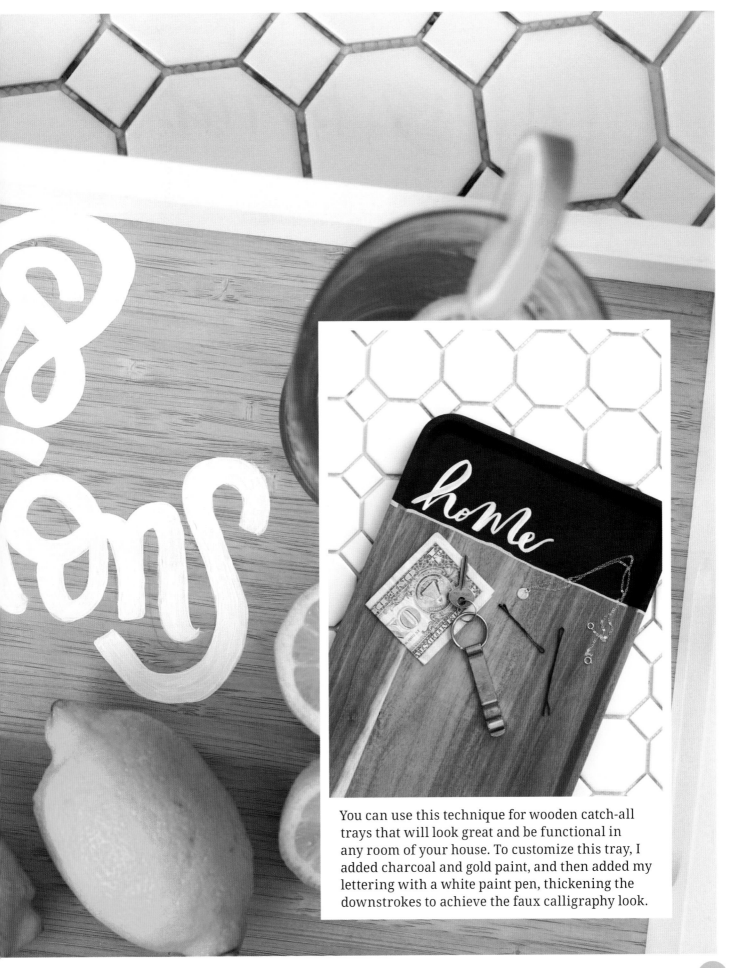

You can use this technique for wooden catch-all trays that will look great and be functional in any room of your house. To customize this tray, I added charcoal and gold paint, and then added my lettering with a white paint pen, thickening the downstrokes to achieve the faux calligraphy look.

DECORATIVE
Cutting Board

You can never have too many cutting boards! And that goes for decorative ones, too. A custom cutting board is one of my favorite thoughtful gift options when it comes time to celebrate a wedding, a housewarming party, or an anniversary.

MATERIALS
- Double-sided wooden cutting board
- Pencil or pastel chalk pencil
- Bowl (to trace)
- Paintbrush
- Black archival ink
- Paint palette
- Water and paper towel (for quick cleanups)
- Eraser

1 For a treated wood surface like a cutting board, I am going to use a waterproof archival black ink. The word "archival" means it won't fade with exposure to sunlight, making it perfect to be displayed anywhere in a kitchen.

2 A little of this ink goes a long way! Drop a little ink into a paint palette or tray and set it to the side. Also prepare a cup of water and a paper towel in case you need to clean off your paintbrush or clean up ink at a moment's notice. This ink is not forgiving, so be careful with your work surface and your clothing.

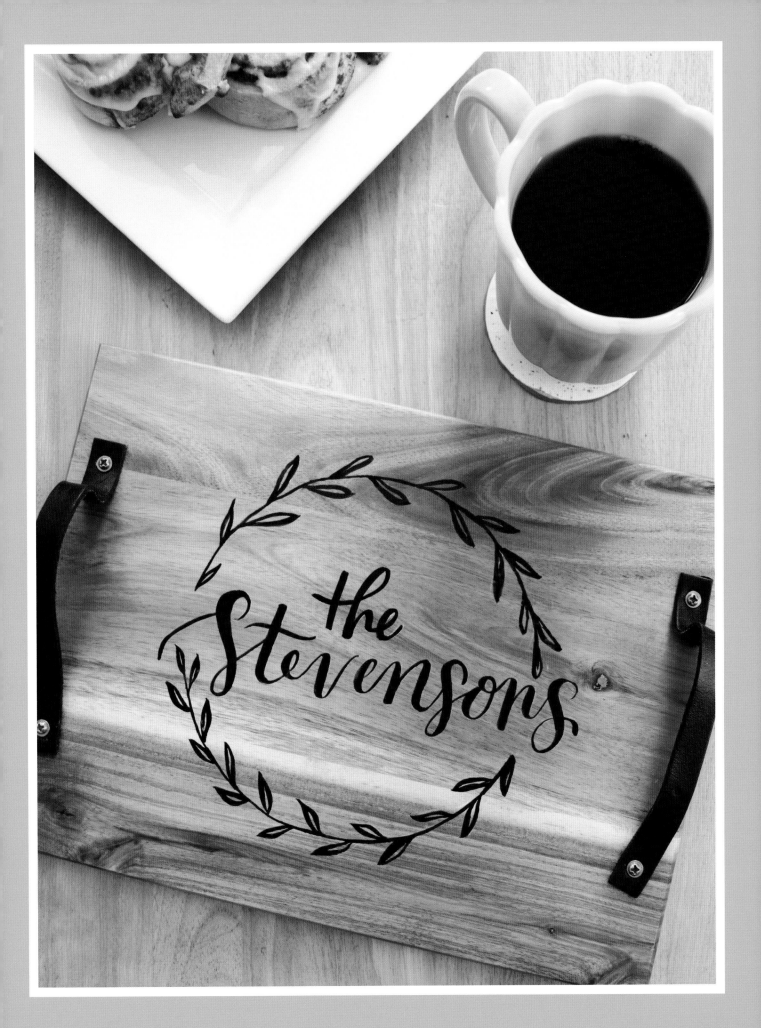

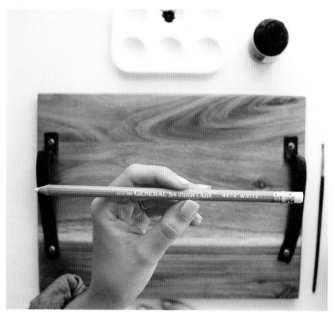

3 My favorite white pastel chalk pencil will show up beautifully on this wood surface, allowing me to sketch my design freely and paint over it without any problems.

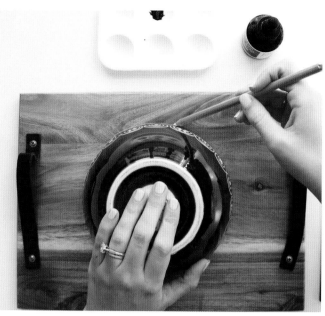

4 For this cutting board, we will create a simple leaf wreath around the name that will be displayed in the center. To loosely sketch the wreath, trace around a bowl whose size works well with that of the cutting board.

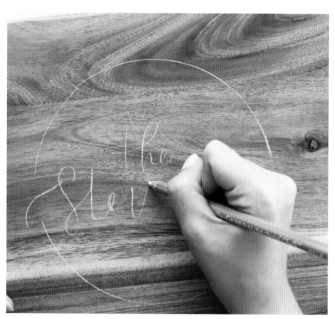

5 Leaving a little space on each side of the wreath, sketch out the name for the center.

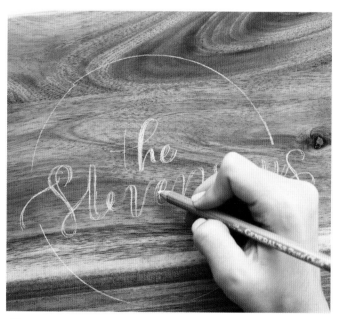

6 Feel free to thicken your downstrokes to make it even easier to paint your design.

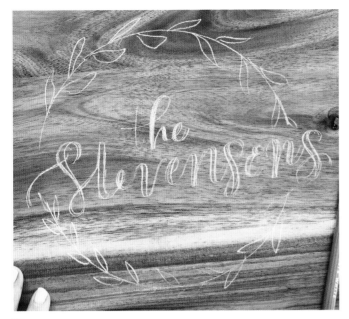

7 Finish off the wreath by alternating leaves on either side of the line. This pattern is very simple; it's one of my tried-and-true methods for adding an extra touch to a custom project.

8 Paintbrush size and shape matter here. A round-tip paintbrush is ideal for lettering with paint. It will allow you to achieve thick and thin strokes, which give you the look of modern calligraphy.

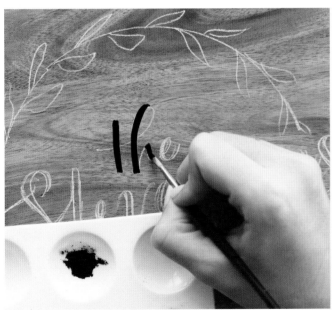

9 When using a paintbrush for lettering, I find it easier to fill in all the downstrokes first. Remember, to achieve thick downstrokes with a paintbrush, apply pressure to the brush tip, much like you do with a brush pen. Paintbrushes are softer and don't require as much pressure. Practice on a scrap piece of paper to warm up before working on your project.

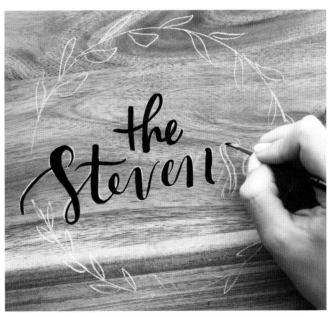

10 Using the thin, pointy end of your paintbrush, add in your thin upstrokes and connecting strokes.

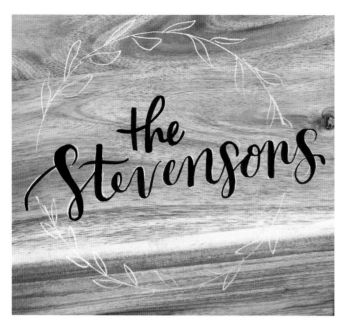

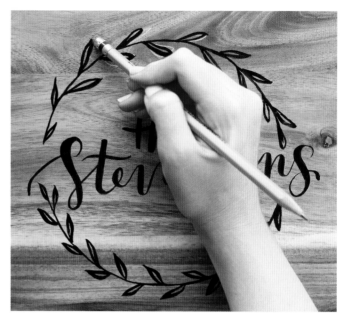

11 Once you are happy with the lettering, paint the wreath. Be careful not to smudge your work as you go; if you prefer, wait until the lettering has dried before tackling the wreath.

12 When all the ink has fully dried, carefully erase any stray pencil marks.

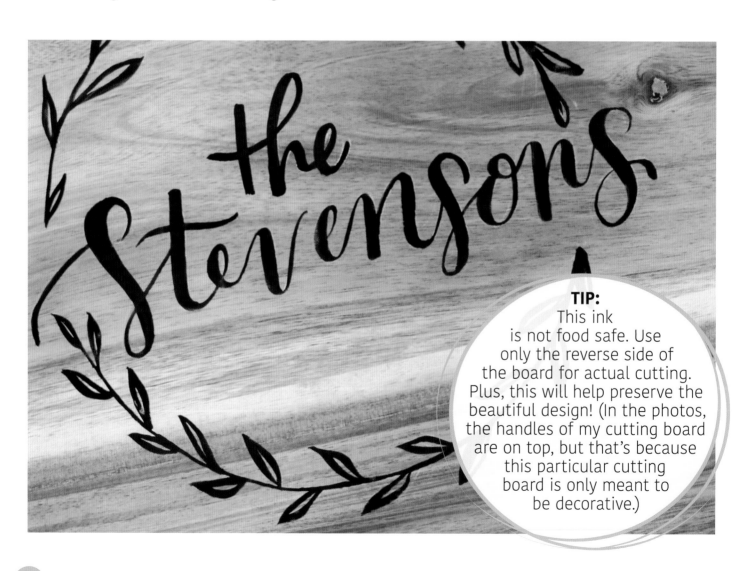

TIP:
This ink is not food safe. Use only the reverse side of the board for actual cutting. Plus, this will help preserve the beautiful design! (In the photos, the handles of my cutting board are on top, but that's because this particular cutting board is only meant to be decorative.)

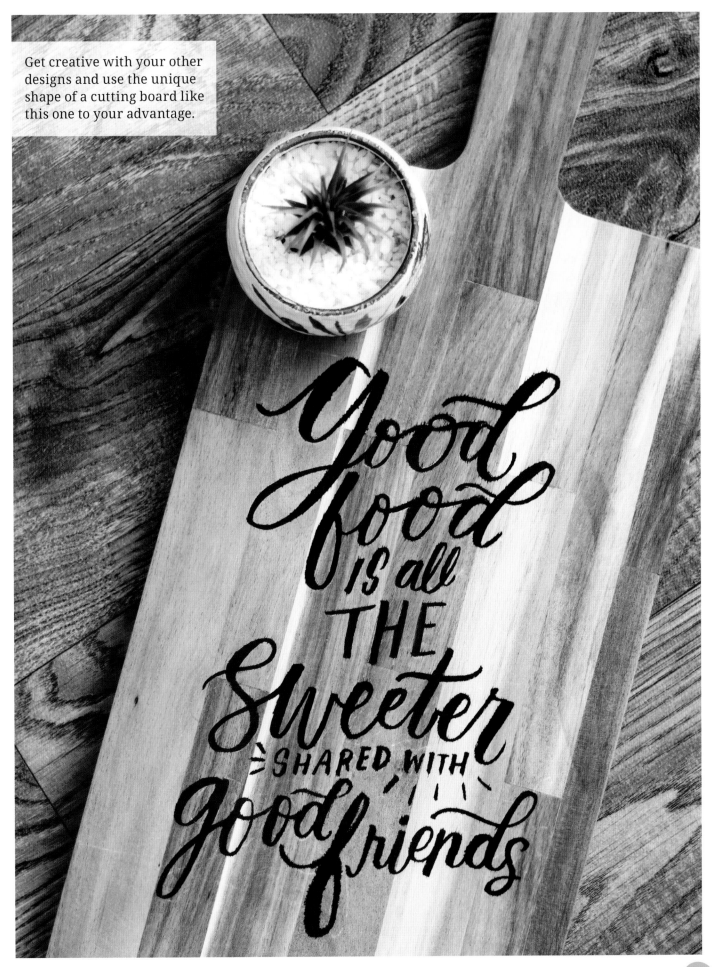

Get creative with your other designs and use the unique shape of a cutting board like this one to your advantage.

Good food is all THE Sweeter SHARED WITH good friends

Coasters

Coasters are so easy to customize in a variety of ways! Not only can you use them in your own home, but they also make thoughtful (and useful) gifts for all occasions.

MATERIALS
- Wooden coasters
- White pastel chalk pencil
- White acrylic paint pen
- Eraser

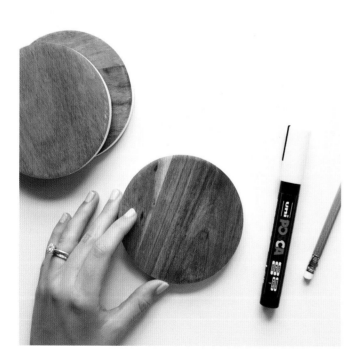

1 I found a pack of blank wooden coasters at my local home store. The circular shape is perfect for customizing with a white acrylic paint pen.

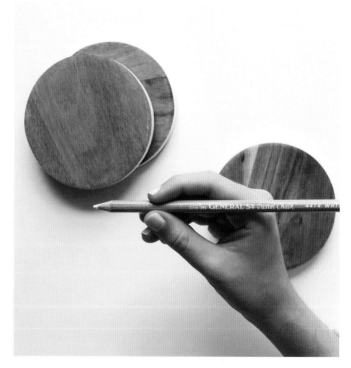

2 To sketch my design, I'm using a white pastel chalk pencil. This pencil will show up on the wooden surface and can be erased at the end.

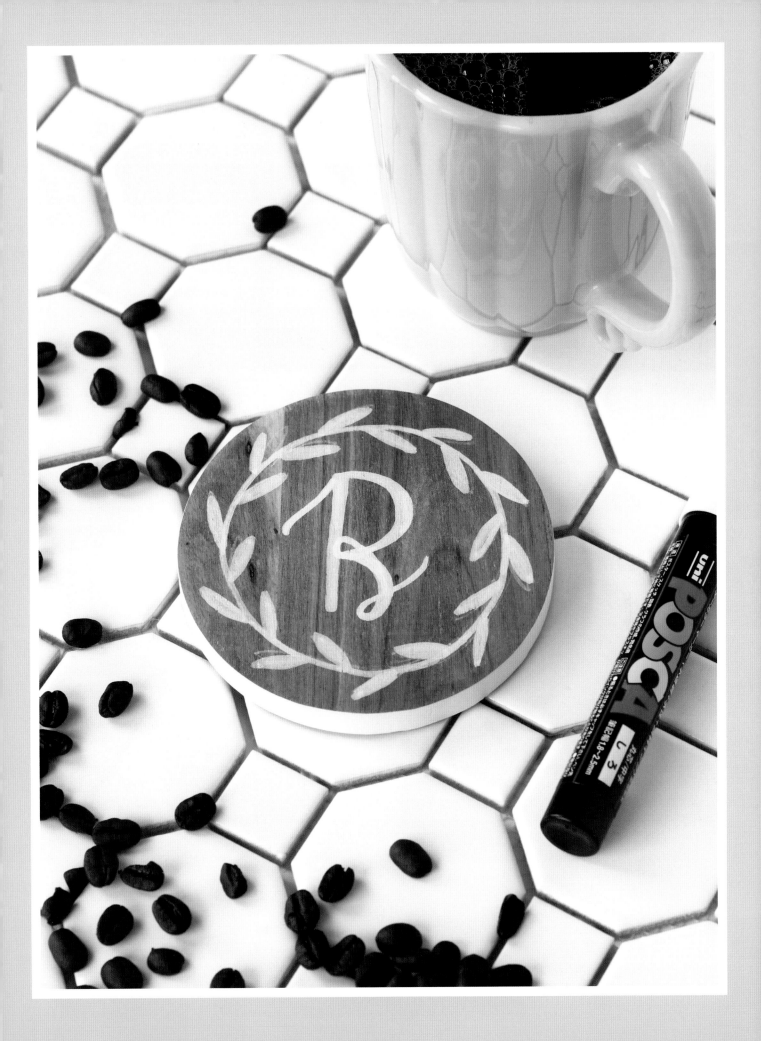

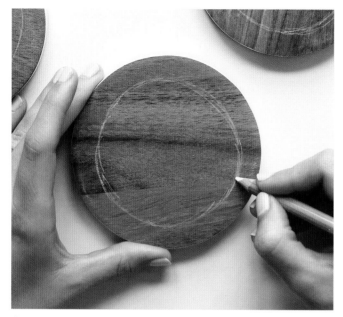

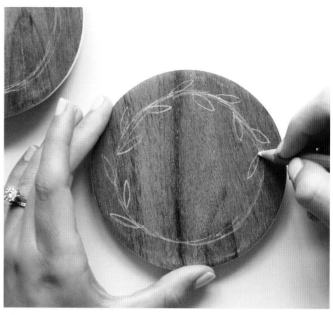

3 To start, sketch a circle within the coaster. Feel free to cut a circle from cardstock to use as a template if you're not confident in sketching an even circle across all the coasters. You could use a small jar or lid to trace around as well.

4 Add a wreath. A simple wreath is so easy to draw! Sketch out a basic leaf shape, alternating leaves on either side of your circle outline.

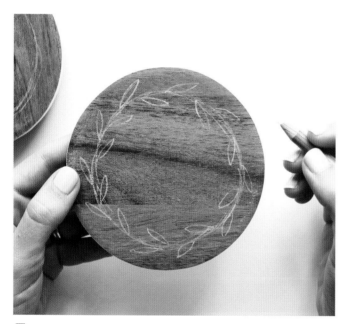

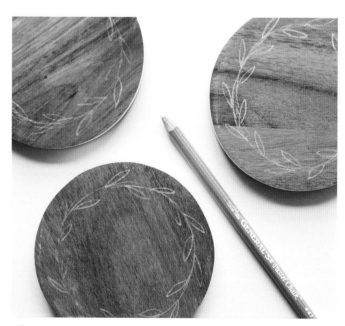

5 If you end up with not enough space to evenly finish out the leaves, just erase the last few leaves and adjust the spacing.

6 Finish the wreath on all the coasters in your set.

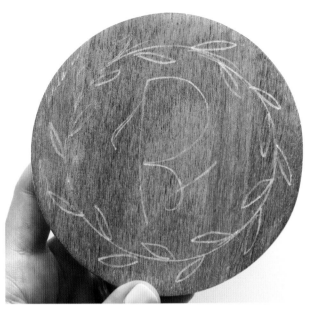

7 To complete the design of each coaster, add an initial in the center of the wreath.

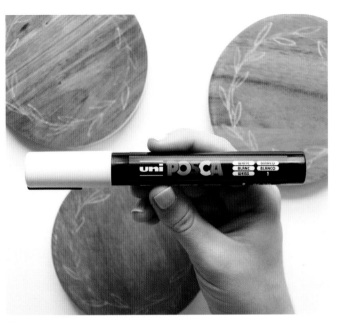

8 This large white paint pen will go right on top of the sketched lines.

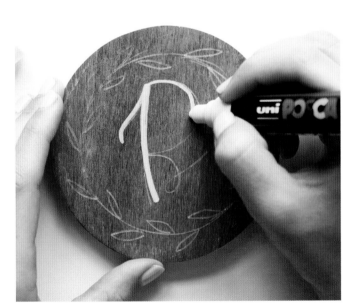

9 Begin painting. Thicken the downstrokes on each initial for a brush-lettered look. Don't forget to fill in the leaves!

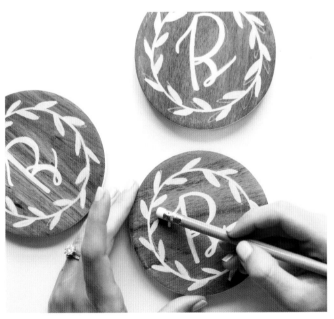

10 That's it! All you have to do now is erase stray pencil marks, and your coasters are complete.

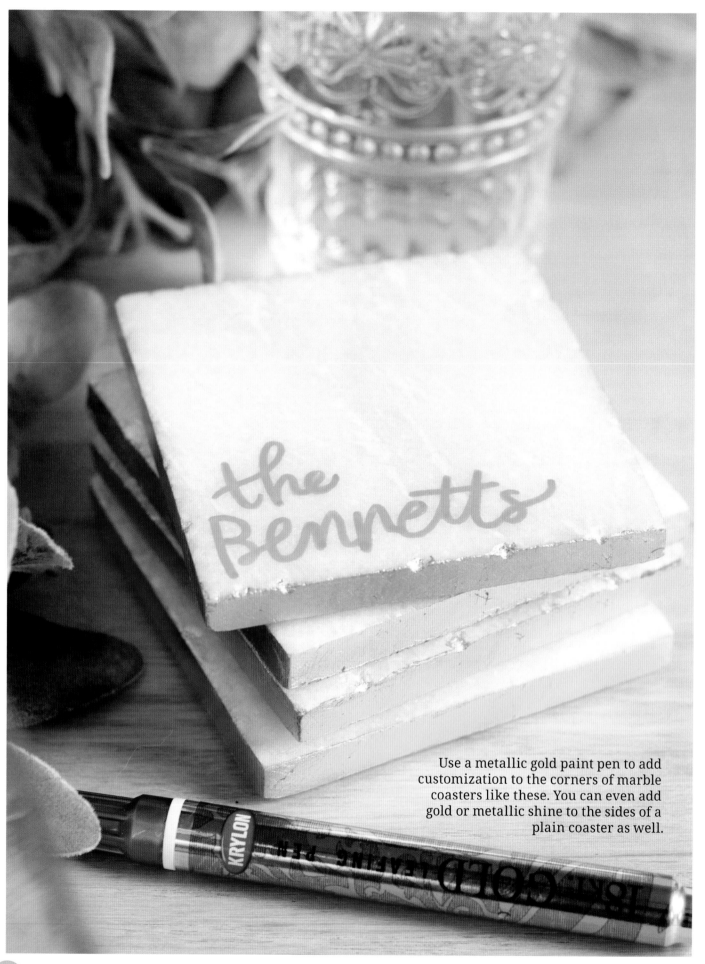

the Bennetts

Use a metallic gold paint pen to add customization to the corners of marble coasters like these. You can even add gold or metallic shine to the sides of a plain coaster as well.

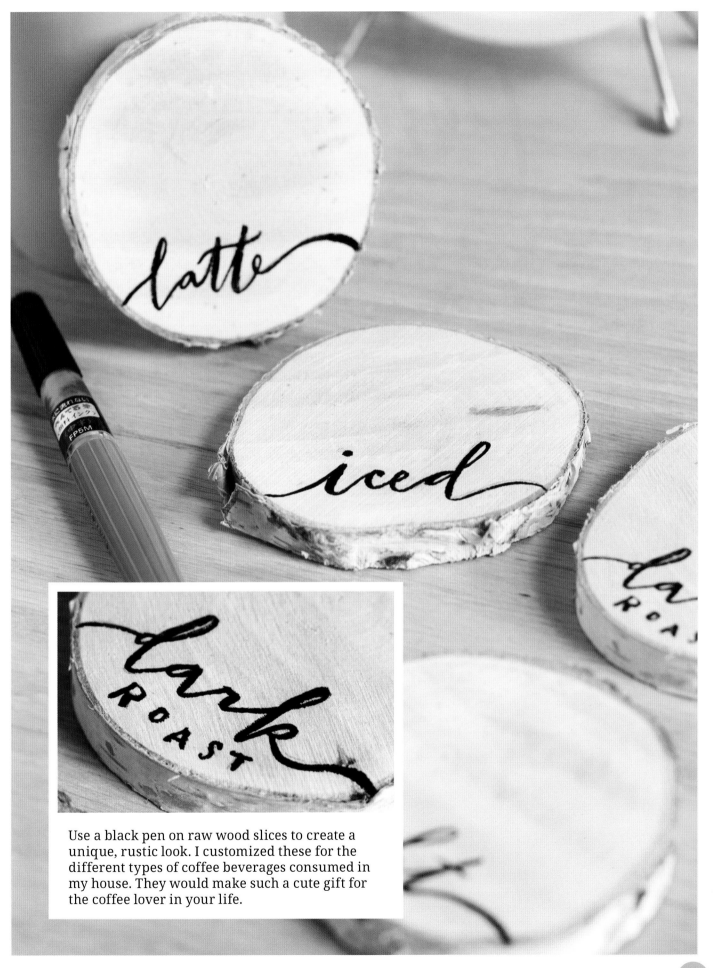

Use a black pen on raw wood slices to create a unique, rustic look. I customized these for the different types of coffee beverages consumed in my house. They would make such a cute gift for the coffee lover in your life.

HAND-LETTERED
Pumpkins

Pumpkins are my favorite fall décor pieces, and they look festive indoors or out! This year, add lettering to your pumpkins to put a new spin on a traditional fall staple. Use them outside on your porch to welcome guests to your home, or indoors to bring autumn inside.

MATERIALS

- Real or fake pumpkins
- Pencil
- Paper
- Eraser
- Tape
- Paint pens
- Markers (optional)
- Paintbrush (optional)
- Paint colors of choice (optional)

1 For this project, I am opting to use a paint pen because I prefer the control it gives me compared to a paintbrush and paint, especially on the rounded surface of a pumpkin. Because I'm using a monoline tip, I need to use faux calligraphy. Sketch out a phrase for each pumpkin on paper first.

2 Cut the phrases out, allowing a thin border around each of them.

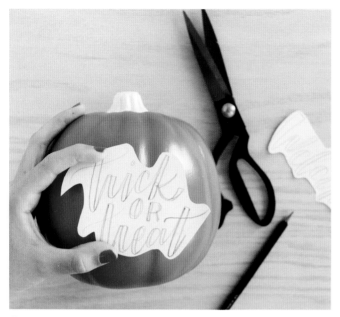

3 Tape or attach one phrase to one pumpkin. With a pencil, mark a faint outline around the edges of the phrase.

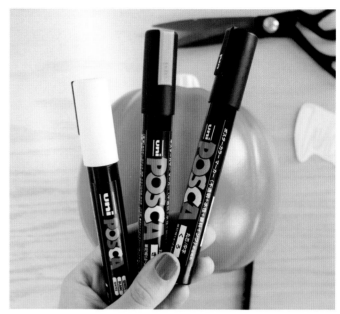

4 These paint pens are my absolute favorite! I'm going to be using white, gold, and black for my pumpkins. Choose colors that will contrast the colors of your pumpkins.

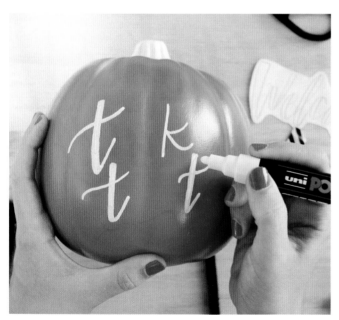

5 With the paint pen, fill in the first and last letters of the phrase. Stay within the faint pencil outline of the phrase and refer to your finished lettering on paper as a guide. This technique works for me, but use whatever technique makes the most sense for you.

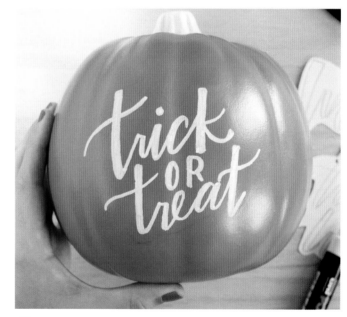

6 As I mentioned earlier, I'm using faux calligraphy here. Make sure to thicken your downstrokes with an extra line from the paint pen to give it that calligraphy look.

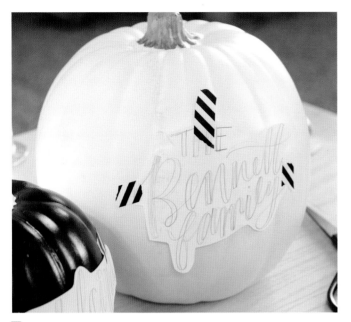

7 Repeat this process on the rest of
 your pumpkins.

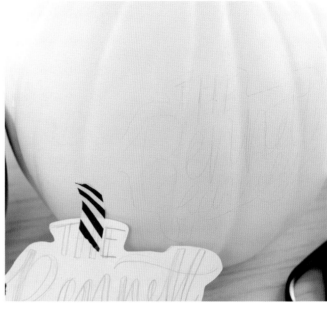

8 If your design is larger or you're less sure of
 yourself, sketch the lettering onto the pumpkin
 inside the traced outline before beginning
 to paint.

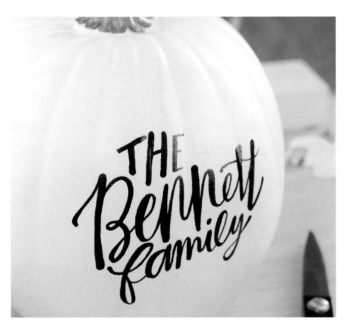

9 Depending on your paint pen and the color of
 your pumpkin, you may need one or two coats.
 You can also use a black permanent marker if
 you don't have paint pens on hand.

TIP:
You don't
have to stick with
just the pumpkin
colors sold in stores!
Paint your entire
pumpkin any color you
want before doing
the lettering.

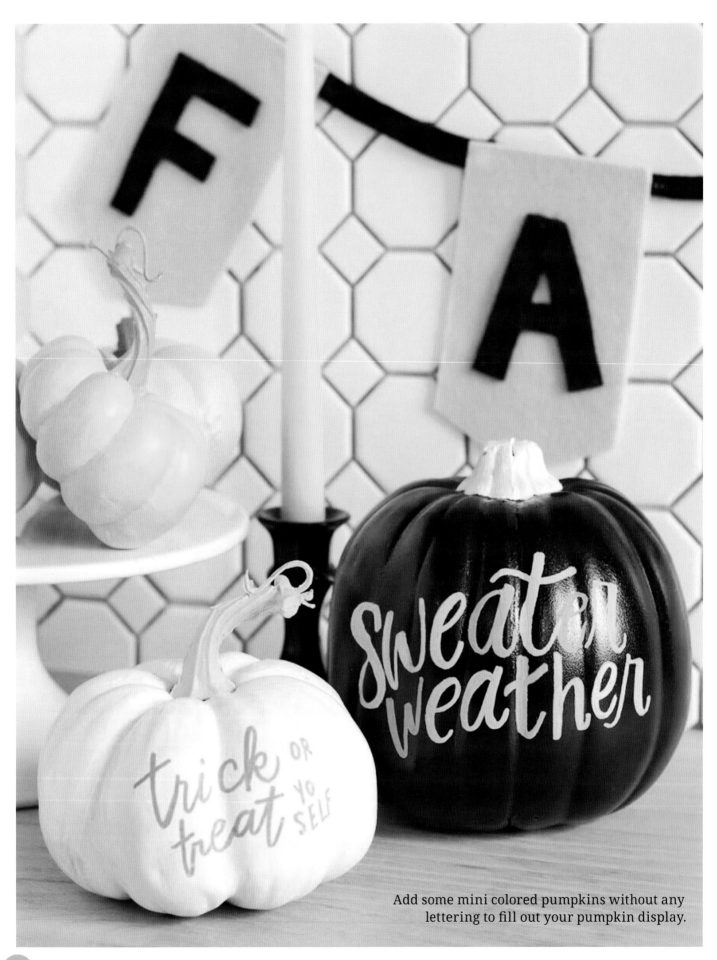

Add some mini colored pumpkins without any lettering to fill out your pumpkin display.

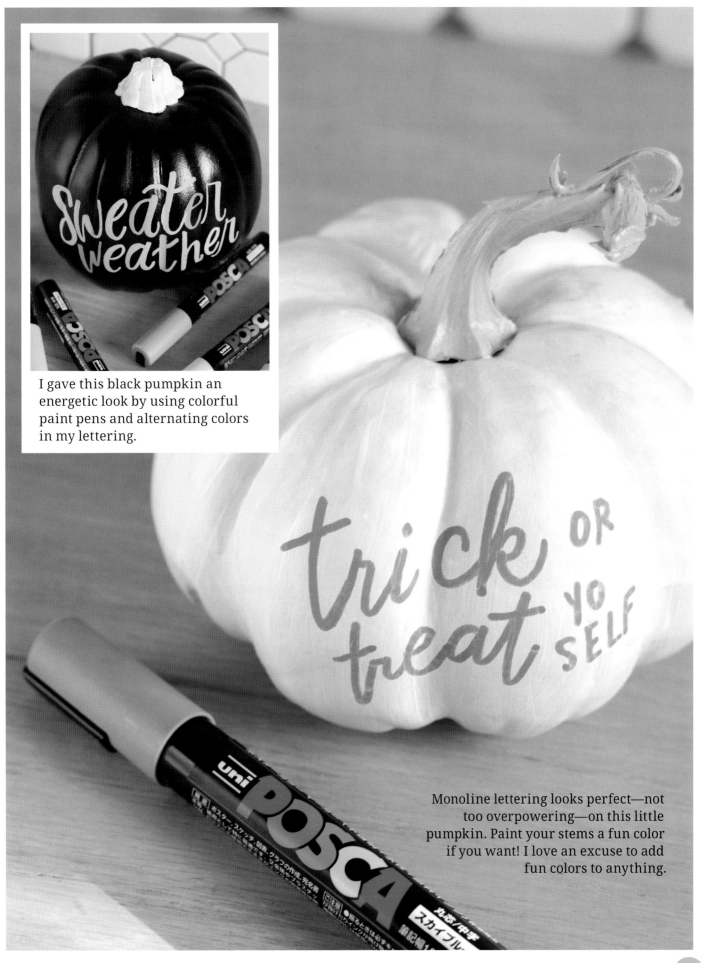

I gave this black pumpkin an energetic look by using colorful paint pens and alternating colors in my lettering.

Monoline lettering looks perfect—not too overpowering—on this little pumpkin. Paint your stems a fun color if you want! I love an excuse to add fun colors to anything.

Christmas Ornaments

There are many ways to customize a Christmas ornament. Make it personal or turn a simple plaster ornament into something a little more special...*and* shiny!

MATERIALS
- Blank ornaments
- Silver paint pen
- Pencil (optional)

1 You can find these plain white plaster ornaments at your local craft store. They come in a variety of shapes that are wonderfully suited for lettering. You could also use wood or acrylic shapes. I'll be using a metallic silver paint pen to add lettering and embellishments—perfect for an icy effect.

2 Starting with the snowman, add the lettering, making sure it's large enough to read. This ornament has limited space, so use as much of it as you need to.

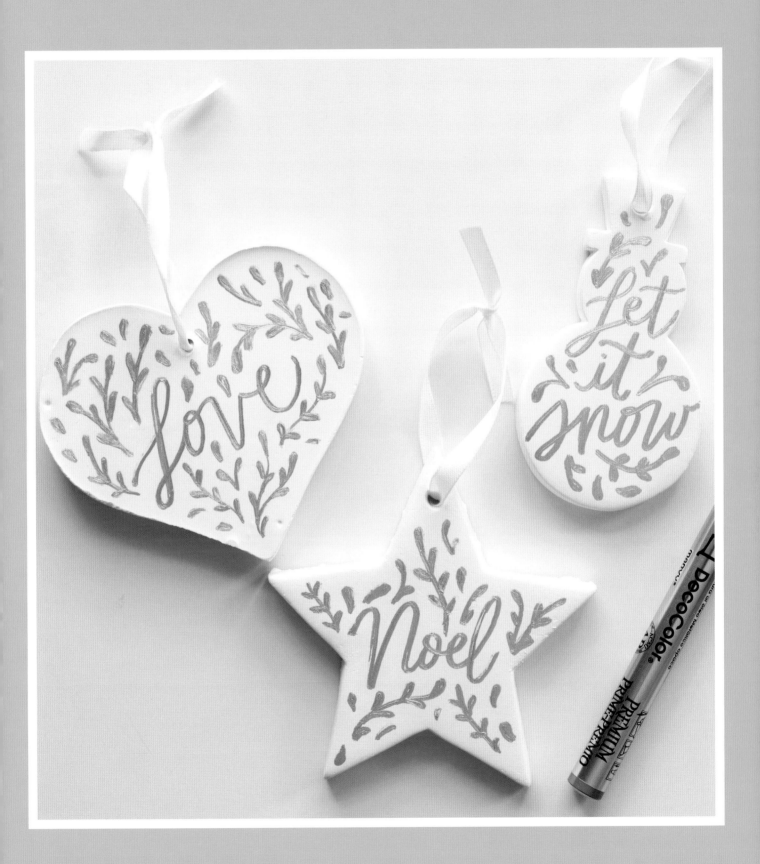

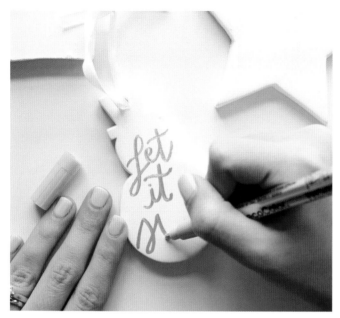

3 Make sure you're confident about each word before starting to letter it—or sketch it on beforehand with a pencil if you're unsure!

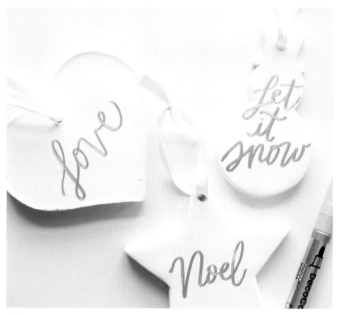

4 Add a phrase or word to each ornament. Next, it's time to fill the rest of the space.

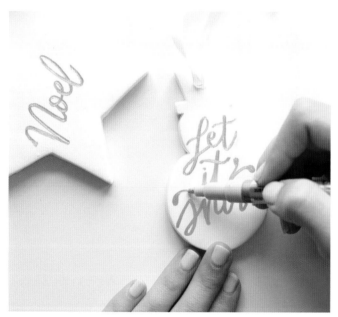

5 Starting anywhere on your ornament, fill in the leftover space with some leaf shapes. They can be as complicated or as simple as you want them to be.

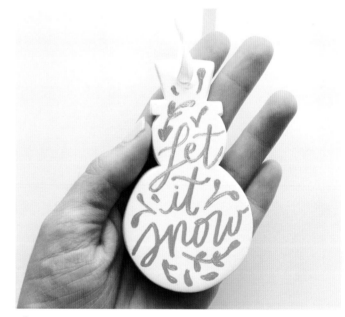

6 Here is my finished ornament.

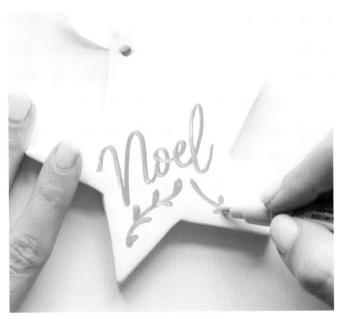

7 Repeat the process for the rest of the ornaments.

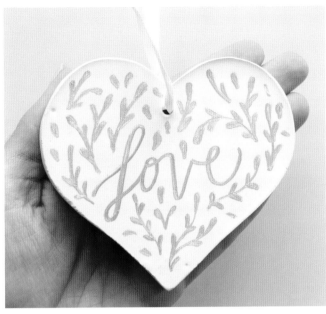

8 These are magical when gifted or hung as a set!

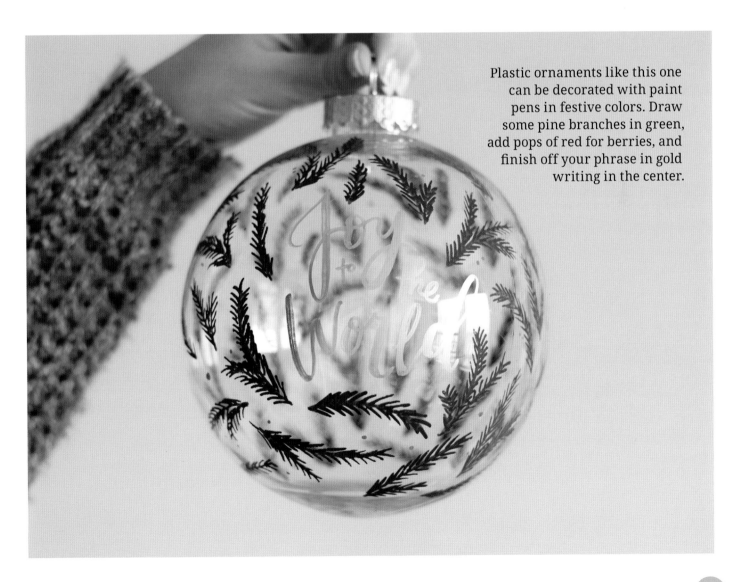

Plastic ornaments like this one can be decorated with paint pens in festive colors. Draw some pine branches in green, add pops of red for berries, and finish off your phrase in gold writing in the center.

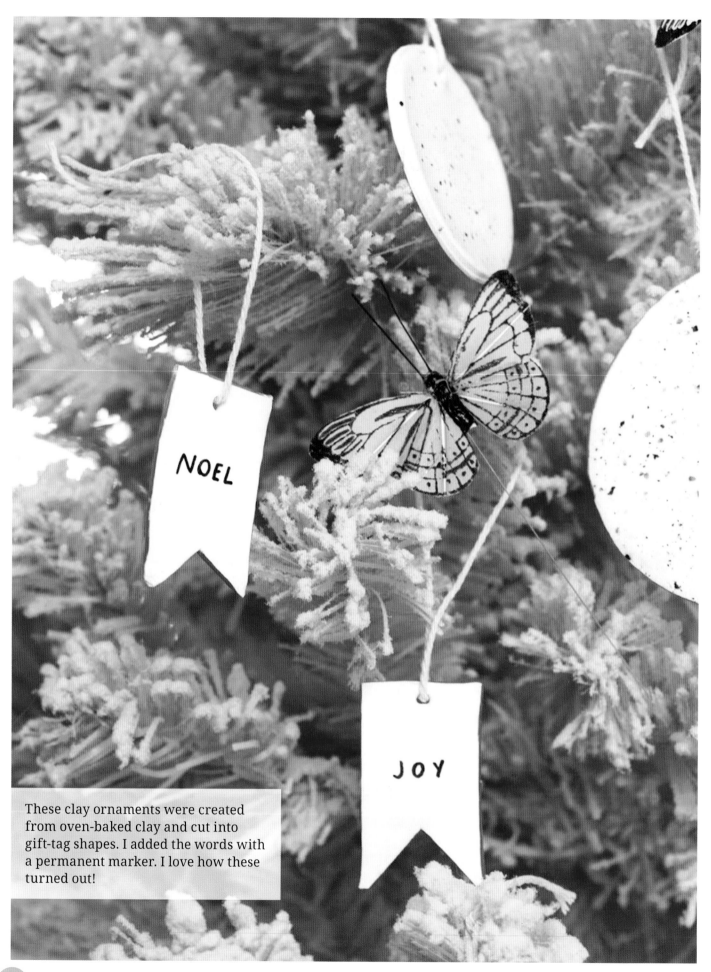

NOEL

JOY

These clay ornaments were created from oven-baked clay and cut into gift-tag shapes. I added the words with a permanent marker. I love how these turned out!

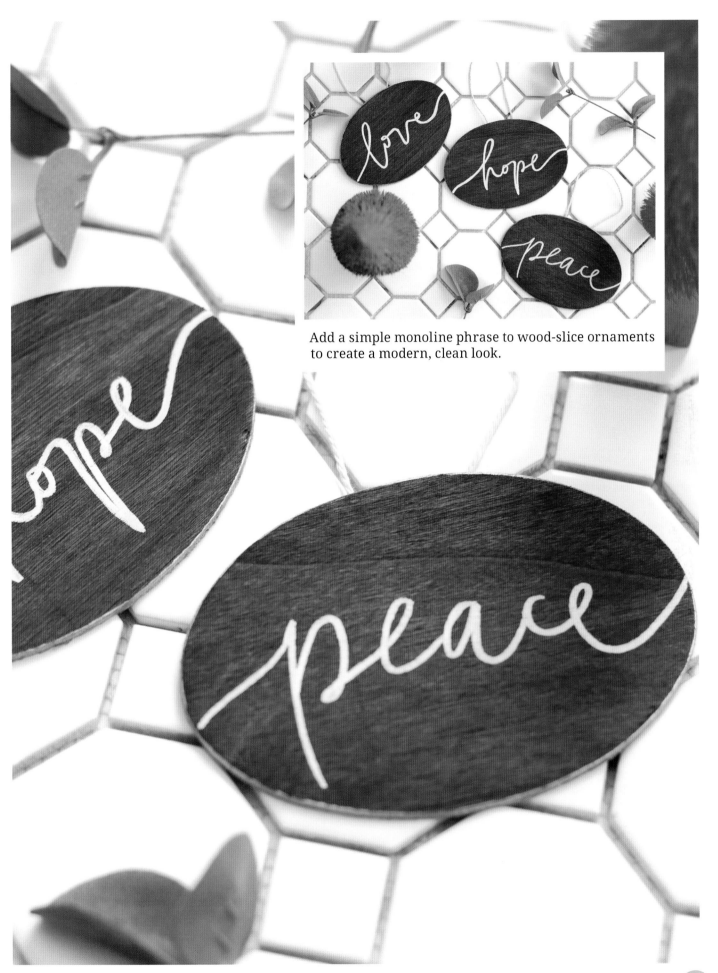

Add a simple monoline phrase to wood-slice ornaments to create a modern, clean look.

DECORATIVE
Chalkboard

Chalkboard designs make wonderfully fleeting art for holidays, birthdays, weddings, and more. The method is forgiving, because erasing is easy—but be careful not to smudge your work!

MATERIALS
- Chalkboard
- Chalk
- Ruler
- Mechanical pencil sharpener
- Soft cloth and cotton buds
- Eraser

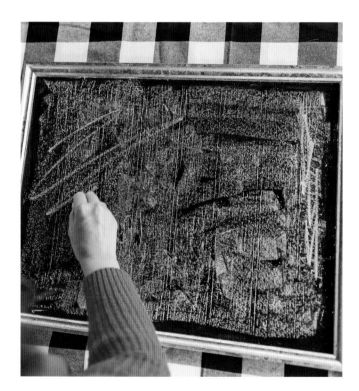

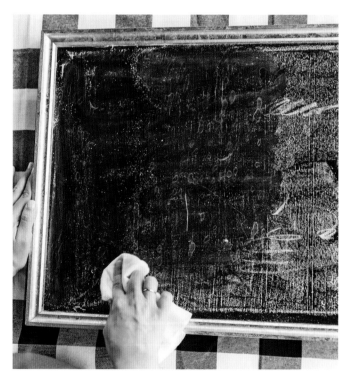

1 When starting with a new chalkboard, the first step is to "season" your board. This is super easy! Cover your board in chalk, in as many layers as you please.

2 Wipe away the chalk with a dry cloth. Repeat the process as many times as it takes to achieve a worn-in look. Don't worry about wiping every last bit of chalk clean from the board—leaving some chalk residue behind will help later when you add dimension to the lettered design.

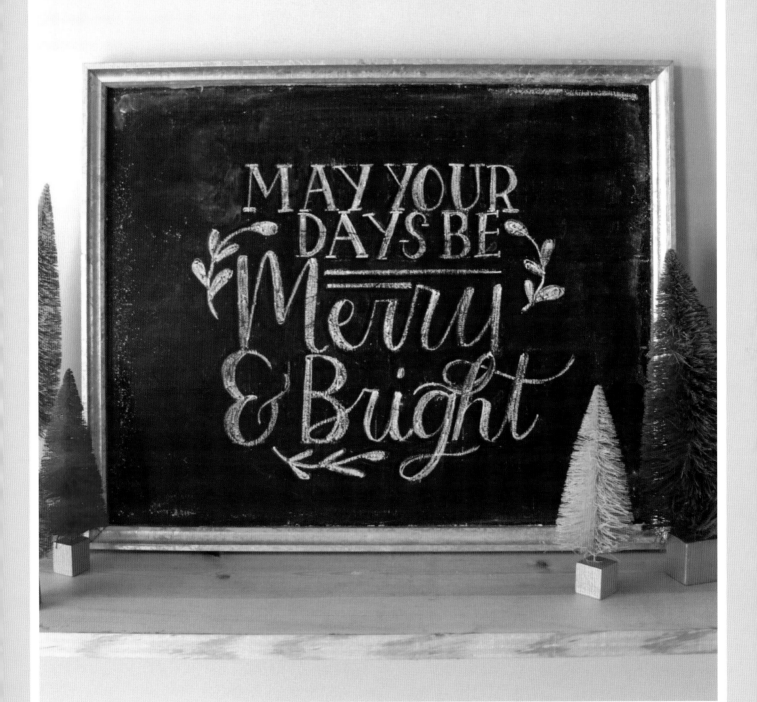

3 Chalk is the primary medium for this project. Because lettering with a flat, dull piece of chalk is more difficult than it is pretty, grab a pencil sharpener and sharpen your chalk. Be very delicate when sharpening chalk—it breaks easily. You will have to continually sharpen your chalk to keep the end pointed for lettering.

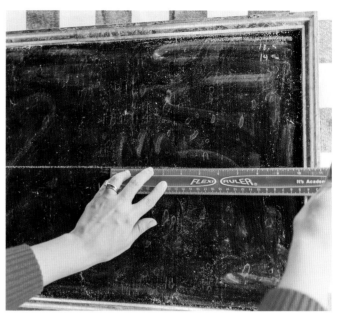

4 Guides for lettered designs are very helpful and easy to make. Using a flexible ruler, measure the chalkboard and use chalk to divide the board into even sections.

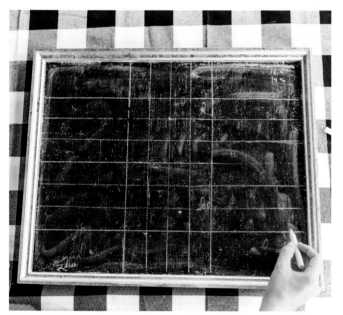

5 I made this grid to help me evenly space my design out. Your grid may look different, depending on the size of your board and the scale of your design. Sketch out a guide that makes sense to you.

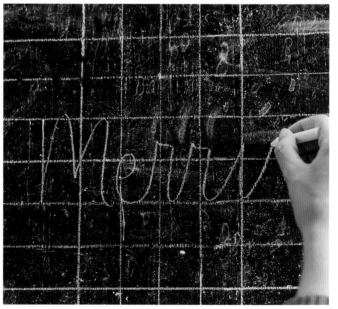

6 Begin lettering. I started with the word that will be central to my design. Don't worry about thickening downstrokes at this step.

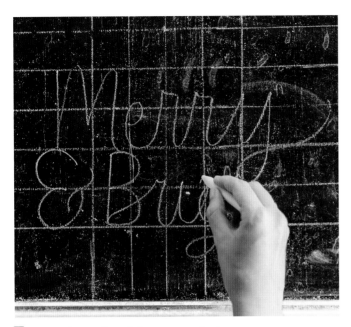

7 Continue sketching your design.

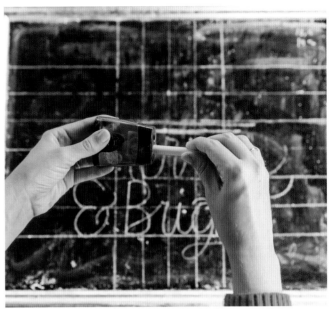

8 Remember to sharpen your chalk frequently.

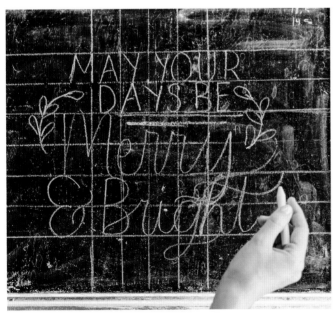

9 When the lettering is complete, add a few embellishments to fill space and add balance. I started with a sprig of leaves on each side of the lettering.

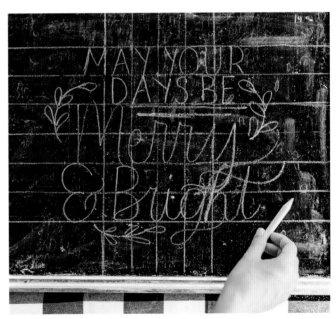

10 I decided that one more sprig at the bottom would help balance out the shape as a whole.

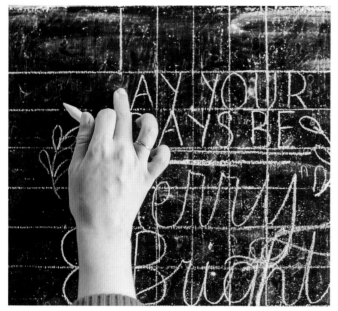

11 The best part about chalkboard lettering is how easy it is to erase mistakes. At this stage, you can just swipe away errors or areas to be adjusted with a finger.

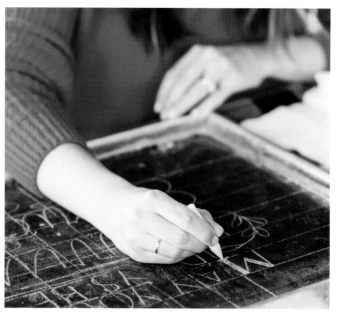

12 Now go back in and thicken those downstrokes.

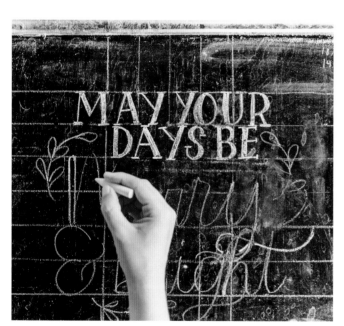

13 I decided to add serif lines to my print words at the top of my design.

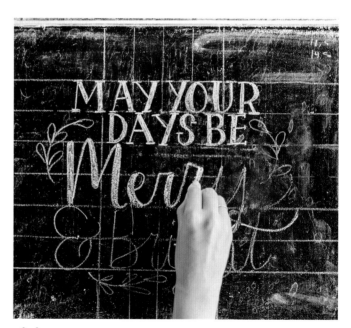

14 Continue to thicken your downstrokes throughout the rest of your design.

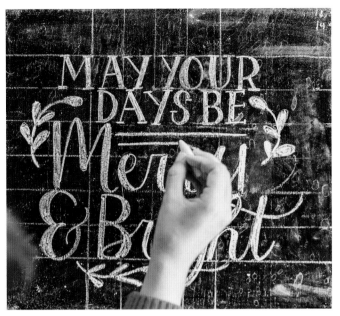

15 Fill in those final details, like the underlining here.

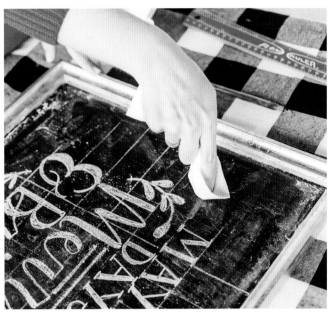

16 When you're happy with your design, use a dry cloth to wipe away the visible gridlines.

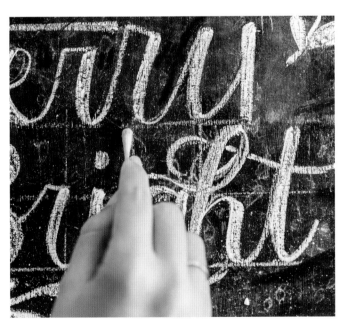

17 For extra-tight spaces, use a cotton bud.

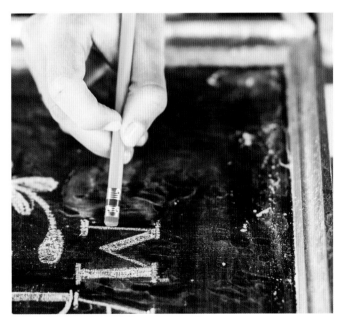

18 Lastly, add dimension by giving the letters a shadow. Use the eraser of a pencil to "erase" a thin line to the left side of all of your strokes, removing the residue to reveal the clean black chalkboard underneath.

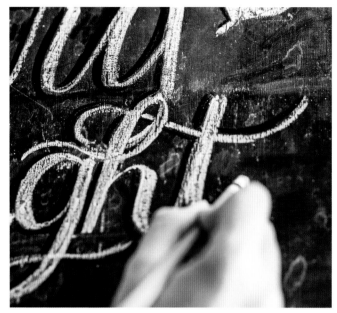

TIP:
Anything can become a chalkboard with a little chalkboard paint, which you can purchase at your local craft store. Follow the manufacturer's instructions to create surfaces that act like real chalkboards.

19 Imagine where shadows would fall on your lettering and incorporate them there. This doesn't have to be perfectly accurate—the effect will shine through beautifully even if it's not quite true to life.

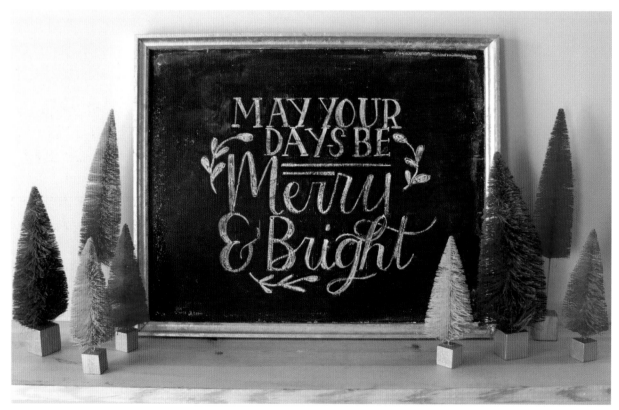

20 Display your finished piece where everyone can see it! And, when the holiday is over, erase it and create a new seasonally appropriate design.

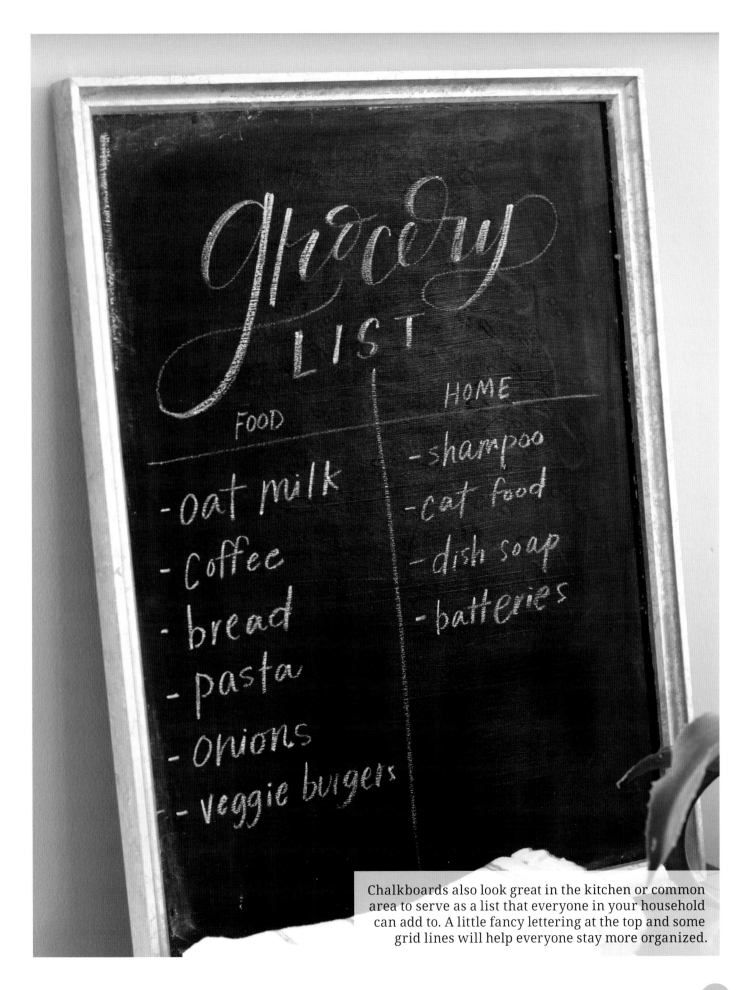

Chalkboards also look great in the kitchen or common area to serve as a list that everyone in your household can add to. A little fancy lettering at the top and some grid lines will help everyone stay more organized.

Cake & Cupcake TOPPERS

There's nothing better than when your dessert is calling for you...*literally*! With this project, you'll learn the simplest way to dress up a grocery store cake or a boxed cupcake mix with supplies you probably already have at home. Cake toppers are versatile enough that they can be easily designed to fit any theme or celebration. Whether it's a birthday, wedding, graduation party, or holiday gathering, you'll be able to whip these up with time to spare.

MATERIALS

- Cardstock in any color or pattern of choice
- Pencil
- Eraser
- Lettering tool of choice
- Scissors
- Cake pop sticks, toothpicks, or skewers
- Adhesive

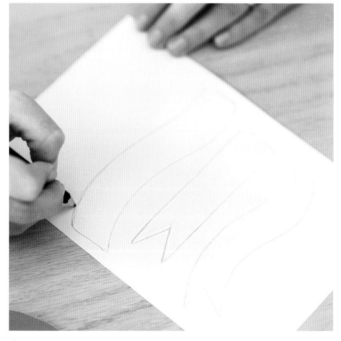

1 Start with a blank sheet of cardstock to sketch out your cake topper shapes. Or see pages 123–124 for some easy-to-use templates to make this project even simpler.

2 When choosing shapes, take into account the size of your treat to ensure you don't end up with a topper that is too big or too small to suit.

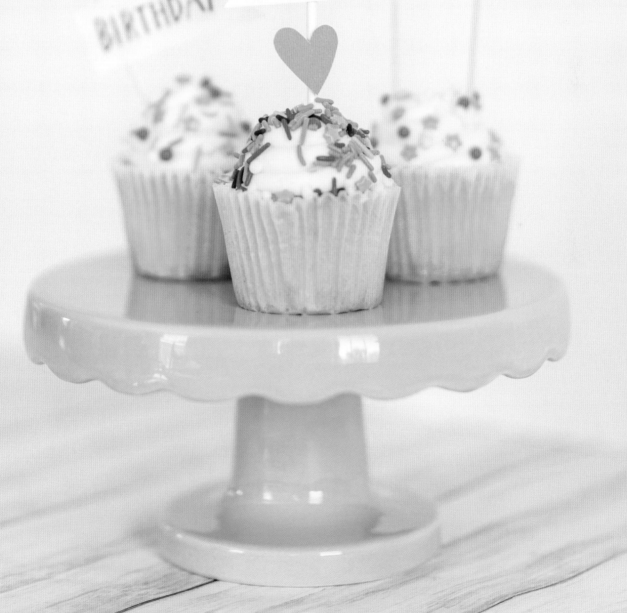

happy

Yay for today.!

HARPER ♥

BIRTHDAY

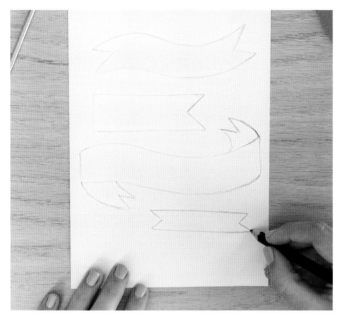

3 Either cut out your shapes now or hand letter your sentiments on them before cutting. It is completely up to you!

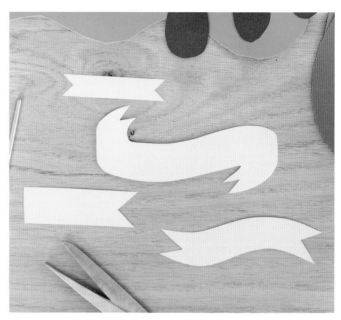

4 I chose to cut my shapes out at this stage.

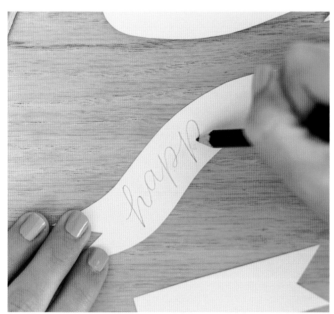

5 Use a pencil to lightly sketch your sentiments before using your final lettering tool of choice. Sketch lightly so you'll be able to cleanly erase any and all signs of pencil after lettering in ink.

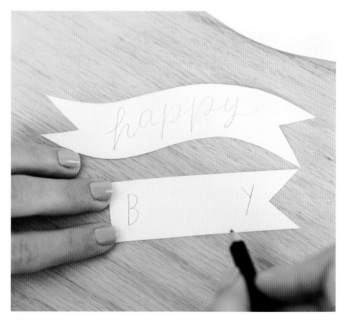

6 It can help to start from the outside and work your way in, as I'm doing with the word "birthday" here.

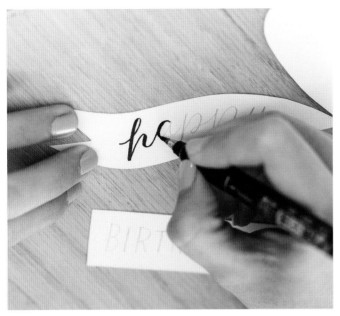

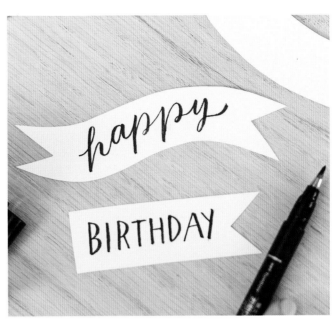

7 My favorite pen of all time is the Tombow Fudenosuke Soft Tip (shown here). I rely on this pen when I want a classic hand-lettered look or a thin, modern brush-lettered style. If you want thicker or bolder brush lettering, try a Tombow Dual Brush Pen instead.

8 The lettering is already done!

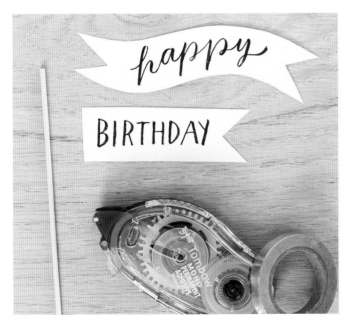

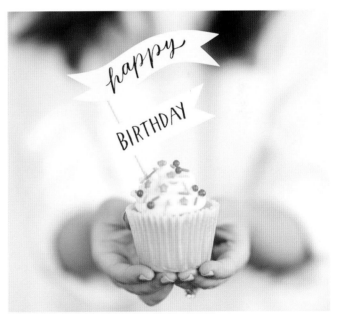

9 Just like that, you're ready to assemble your cake toppers. Use a strong adhesive to attach the stick, toothpick, or skewer to the back of the topper. For this cupcake topper, I am attaching two banners to a single tall stick, adhering it on the back left side. Check the templates on pages 123–124 for suggestions on where exactly to place your topper sticks.

10 Insert your topper into your baked goods so that the paper banner "flies" above the food!

For a vibrant look, cut a variety of shapes from colorful cardstock and add them surrounding a hand-lettered banner. This will make a real statement. (Just be cautious lighting candles near the paper!)

CELEBRATE

These modern toppers are as simple as they look. Go with a brush-lettered monogram or cut a simple phrase from cardstock to create these pretty birthday or anniversary toppers. Gold monoline lettering looks understated and refined.

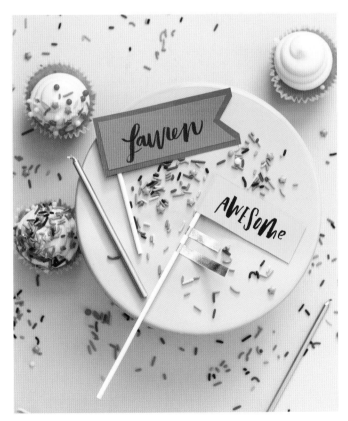

Layer one color of cardstock under another for a border effect.

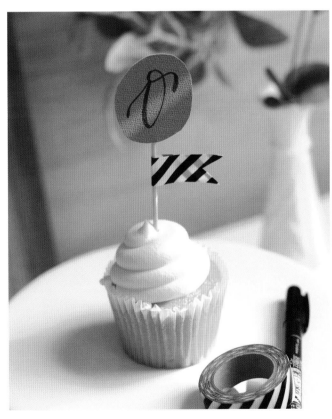

Wrap some coordinating washi tape around the topper stick to create something that matches your party's color scheme.

place cards

Place settings are the finishing touch for any celebration! The best part about them is how easy they are to create. Using a pack of store-bought place-setting cards (or copying the card template from page 125), you can create any of three beautiful, simple styles to add that personal touch to your next wedding or dinner party.

MATERIALS
- Blank place-setting cards or cardstock and scissors
- Pencil
- Eraser
- Lettering tool of choice
- Brush markers
- Metallic pens

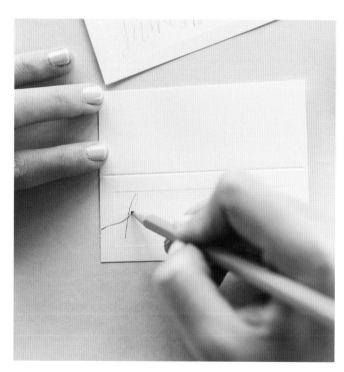

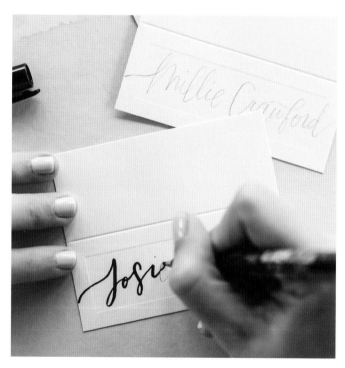

1 The first style is a modern brush-lettered look. Starting with a pencil, lightly sketch the guest's name onto the card. I started at the left edge of the card with an extending line. I will do this on both sides of the card so it looks like the name flows off the edges.

2 Time to ink! I love the Tombow Fudenosuke Soft Tip for this project. If you prefer even thinner lettering, try the Fudenosuke Hard Tip.

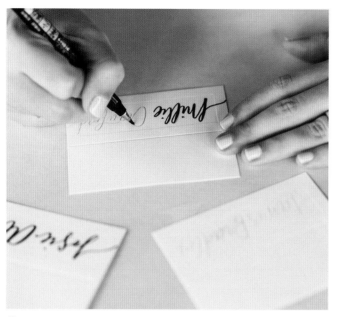

3 Take your time lettering over each name. This is the fun part!

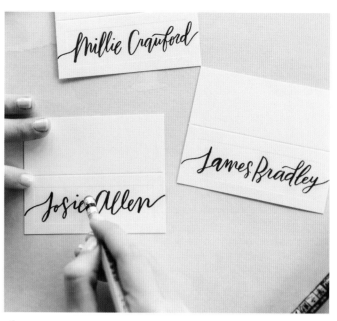

4 Gently erase any visible pencil marks, and then this style is done!

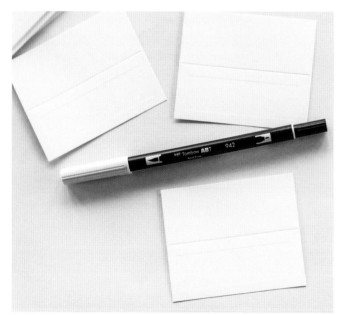

5 For the next style, I'm adding a pop of color with a brush pen in a very light shade. I used a Tombow Dual Brush Pen in shade 942, but experiment with colors you like.

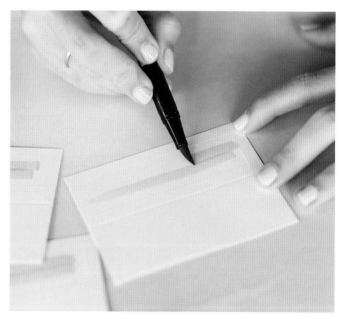

6 With the pen, make two slightly overlapping swashes across the center of the card. This creates a light-colored background that adds interest to your final look.

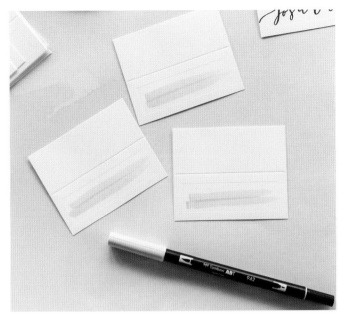

7 Each background is slightly different, which makes the pieces look handmade rather than computer generated—exactly what you want.

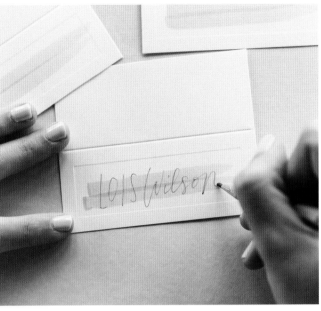

8 Using a pencil again, sketch the name of your guest. For this style, I am using all caps for the first name and a script for the last name.

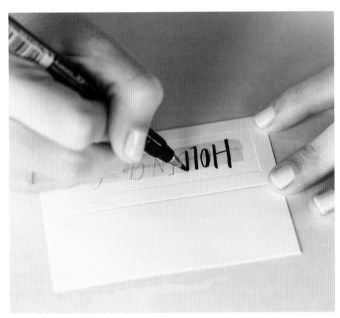

9 Add your ink. I'm still using the Tombow Fudenosuke Soft Tip here.

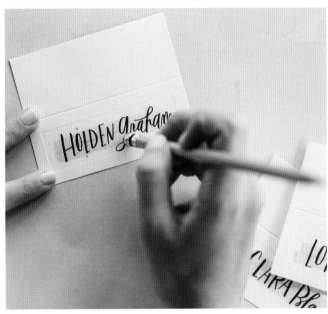

10 Lightly erase any visible pencil marks. These are done!

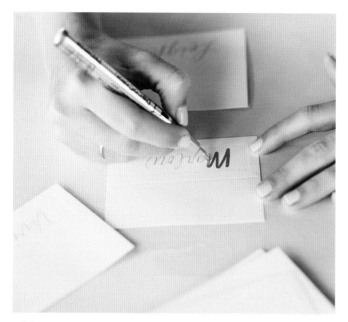

11 For the final style, I am using a gold metallic pen to create a shiny monoline look.

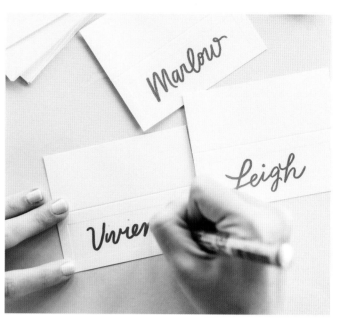

12 I opted to use only the first name for this style. This is the easiest style of them all, but it looks so beautiful!

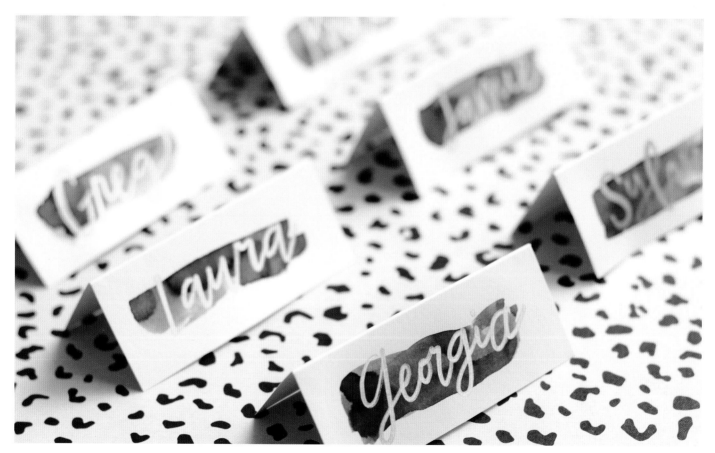

A black ink wash behind gold metallic lettering looks bold and chic.

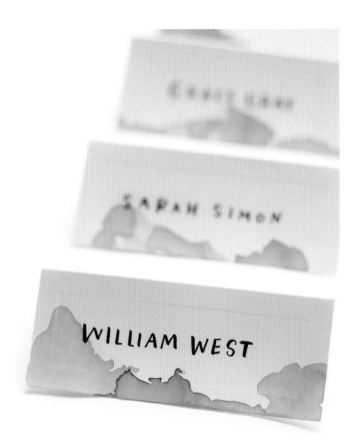

Add some watercolor washes to the bottoms of your cards in colors that fit your theme to really make a statement.

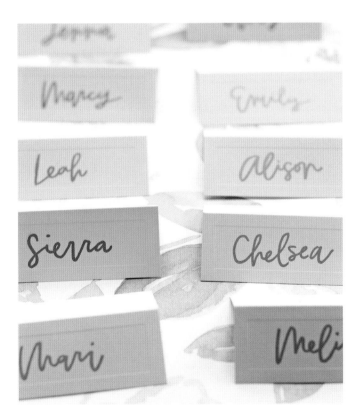

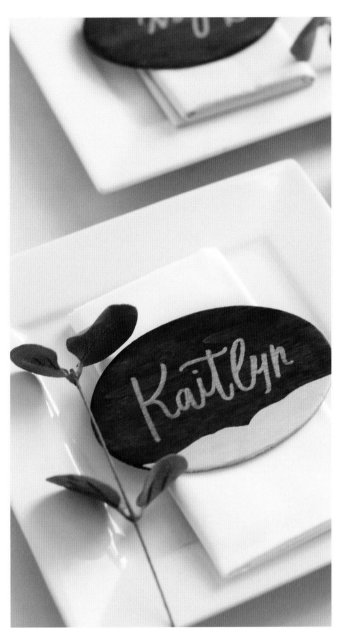

Place settings don't have to be limited to paper. These wood slices look gorgeous with some gold and white paint, and they double as party favors!

Choose a color based on the mood of the party. A silver metallic pen is more classic and not quite as luxurious as the gold pen.

Glass Signs

Glass signs are super popular for weddings and other celebrations, and they're so simple to create if you have any extra picture frames or mirrors lying around at home. I'll be using a paint pen to create a welcome sign for a wedding ceremony. You'll be surprised how quickly this can be done!

MATERIALS

- Glass frame or other glass or mirror item
- Pencil
- Paper
- Eraser
- Ruler
- Glue (optional)
- White paint pen

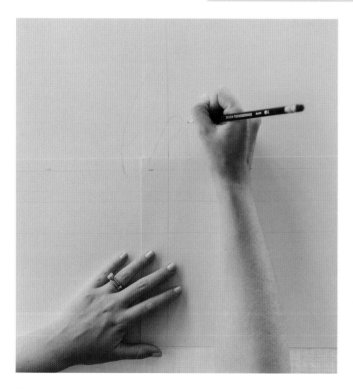

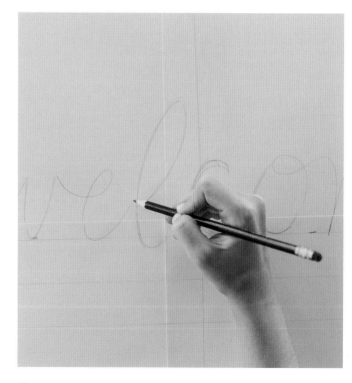

1 To start, measure your glass frame. Then tape together pieces of paper until you have a paper template the size of the frame. You will be sketching your design onto this paper template.

2 Use a ruler to section the paper into quadrants or whatever divisions make sense for your design. I started sketching the large "WELCOME" first and will add my smaller lettering afterward.

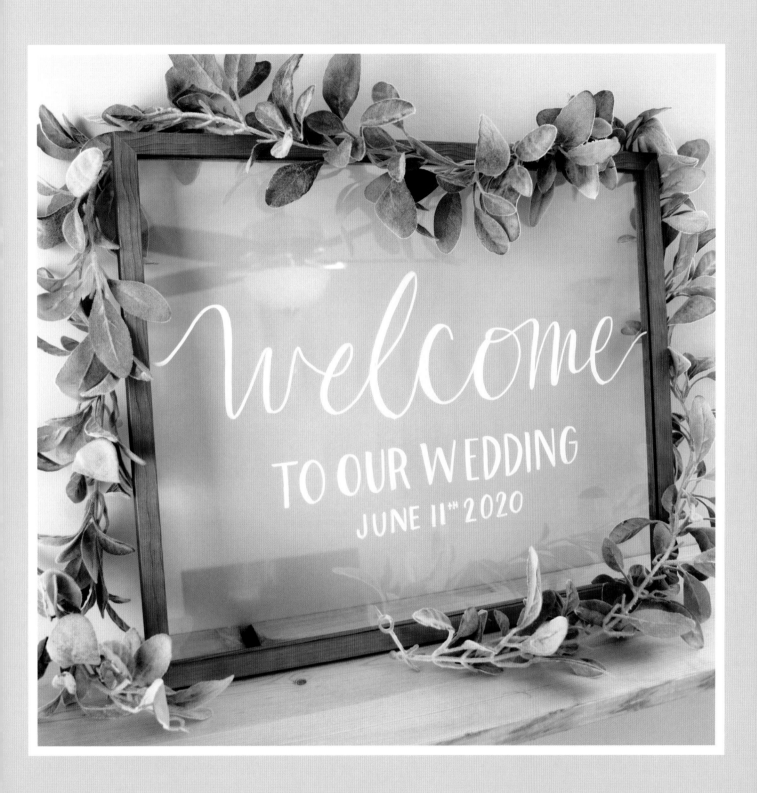

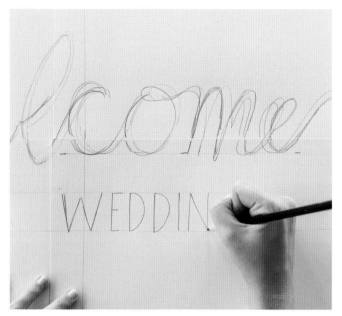

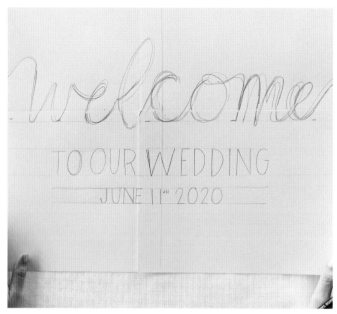

3 To ensure that the line of print lettering below stayed even, I started in the center of the paper with my center letter (in this case, the "W" in "WEDDING"). In some cases, on large-scale pieces, it's easier to start in the center and work outward like this.

4 It looks far from perfect at this point, but it will quickly come together in the next step.

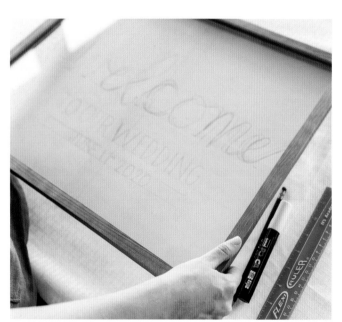

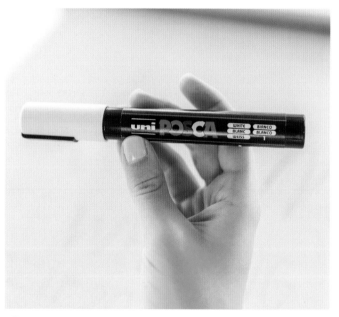

5 Lay your glass frame on top of your sketch. I am using a floating frame, but you can remove the backer from a regular picture frame as well. Simply secure your glass panel to the inside of your frame with glue.

6 This paint pen is my trusty sidekick for lettering on glass. It uses acrylic paint, which has the advantage of not accidentally rubbing off when it's completely dry. You can, however, scrape or scratch it off the glass when you're done with your sign and reuse the glass frame time and time again for a variety of projects.

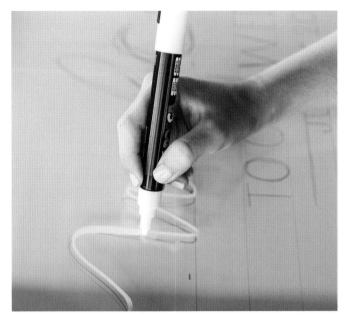

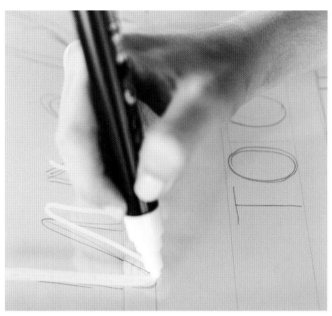

7 With your glass frame neatly aligned with your sketch template, begin lettering directly on the glass with your paint pen. Make sure you are standing right over your glass frame to perfectly match up your sketch with the placement on the glass.

8 Make sure to thicken your downstrokes by adding an extra line of paint to achieve the faux calligraphy look.

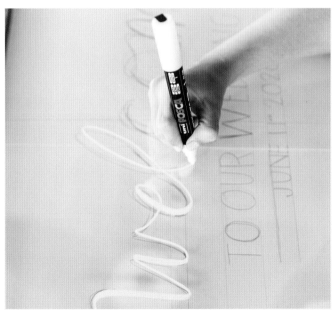

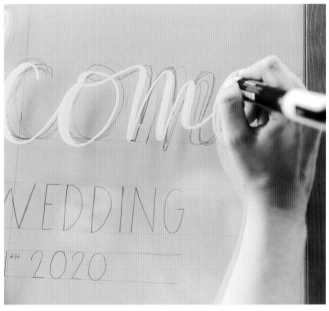

9 Continue filling in your painted letters, remembering to go slow and take your time. Use glass cleaner and a dry cloth to remove any mistakes while the paint is still wet. If the paint dries, use a small scraper or scratch off any areas you want to redo. You may have to use glass cleaner to fully clean the area before you continue.

10 It's not important to follow your sketch exactly. Use sketches as a guide, not as a requirement.

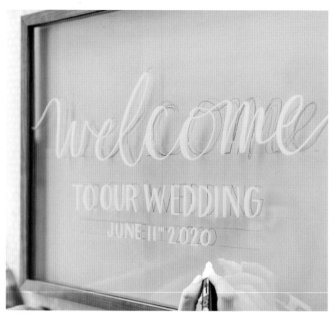

11 Continue filling in the rest of your sign until you are happy with the result.

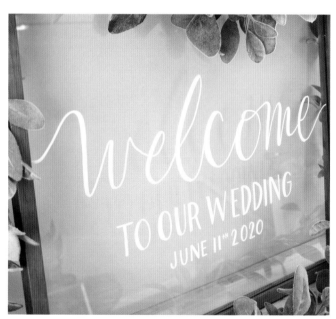

12 That's it! Remove the backing and reveal the finished look. Your welcome sign is complete and ready to be displayed.

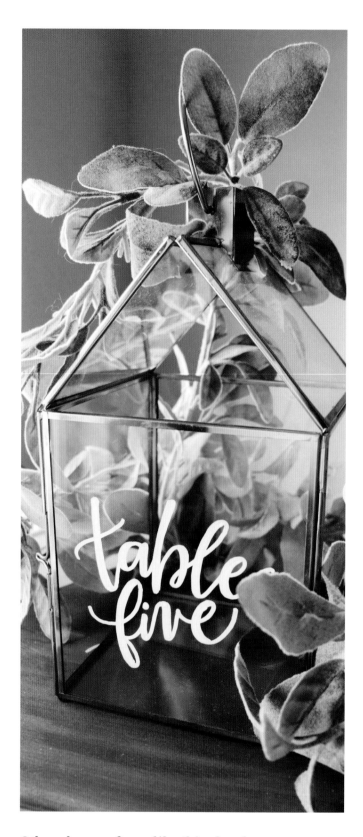

Other glass surfaces, like this glass lantern, are also easily customizable and functional at weddings or other large gatherings. This table marker is achieved in much the same way as the large glass sign. Tape your sketch template to the inside of the lantern and then letter on top of the glass with your paint pen.

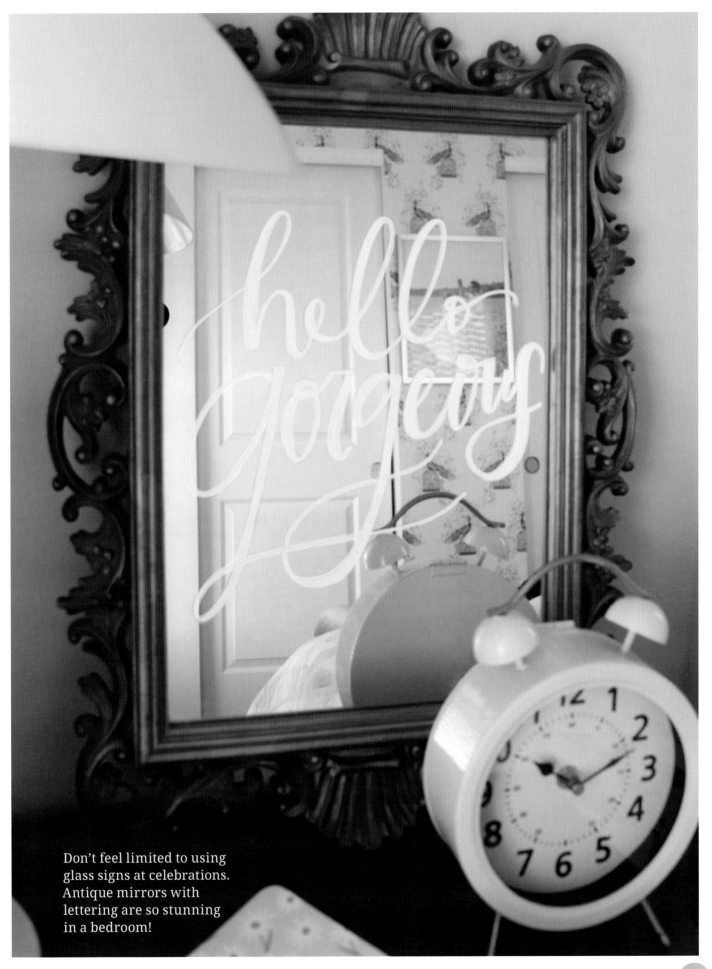

Don't feel limited to using glass signs at celebrations. Antique mirrors with lettering are so stunning in a bedroom!

Gift Tags

Gift tags can make your gift even more special by adding that handmade touch. Check out the templates on pages 125–126 for gift-tag shapes to use when creating your own. In this project, you'll learn several styles to choose from.

MATERIALS

- Blank gift tags or watercolor paper and scissors
- Pencil
- Eraser
- Watercolor palette
- Thin round-tip paintbrush
- Wide flat-tip paintbrush
- Brush pen or ink brush

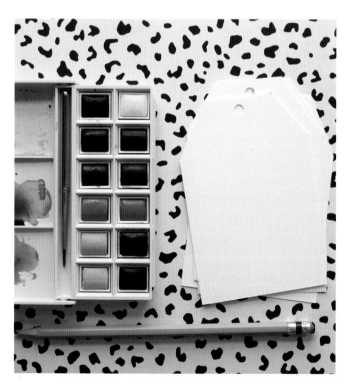

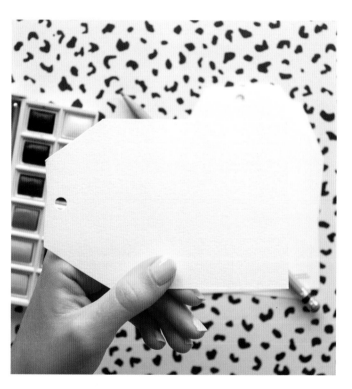

1 Watercolor gift tags are my all-time favorite! We'll be making several styles. For the first, you will need to use your thin round-tip paintbrush, plus all the basics, like the watercolor palette and pencil.

2 For best results, cut your own tags from heavy watercolor paper. Watercolor paper is made to withstand water without buckling, which is perfect for our needs!

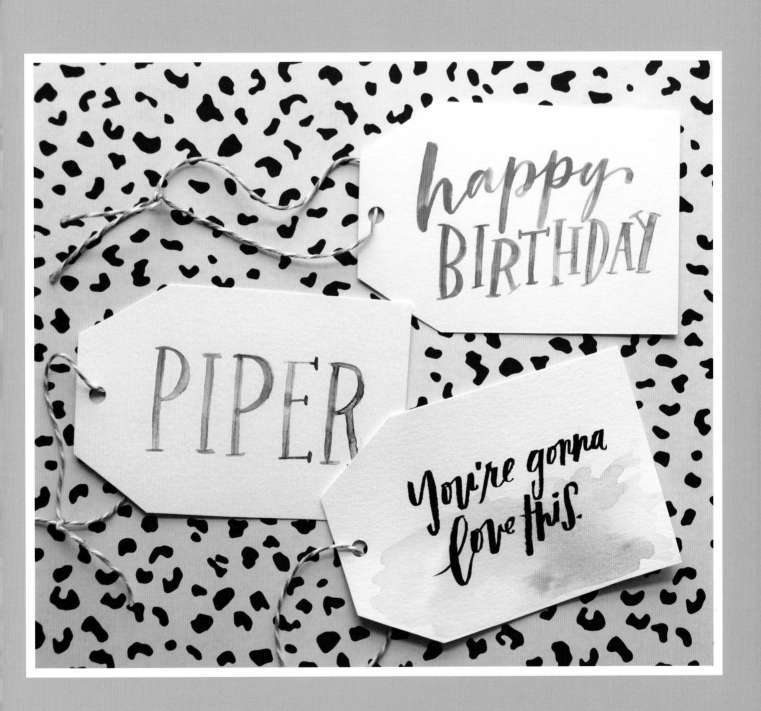

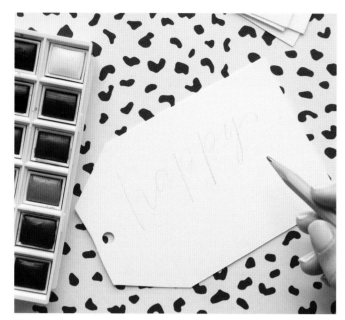

3 With a pencil, lightly sketch your design onto the tag. I intend to mix lettering styles for more interest, so I'm starting with the word "happy" in a script.

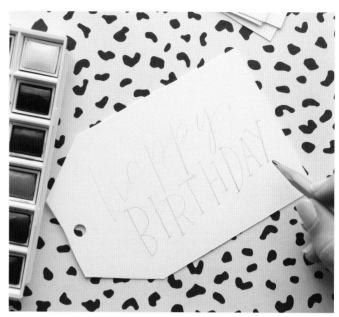

4 I'm following this with the word "birthday" in a simple serif lettering style. It doesn't have to be perfect—imperfections add personality.

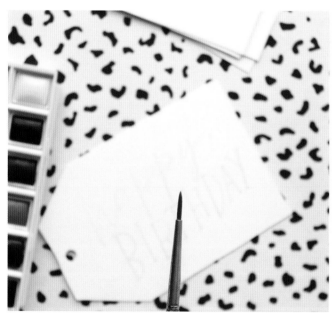

5 This delicate round-tip paintbrush came with my watercolor set, but you can use any round-tip paintbrush you have on hand. The important thing is that it is small and thin.

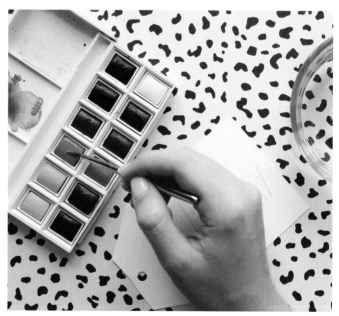

6 Wet your brush and dip it in your first color of choice. I'm going with a pretty orangey-red. To make sure you have the right consistency, test your watercolor on a scrap piece of paper first. You don't want it to be too thick and chalky, nor do you want it thin and runny. Find the happy medium—then you're ready to start painting.

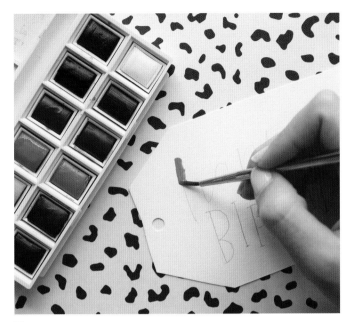

7 Remember, to achieve thick downstrokes with a paintbrush, you should apply pressure much like you do with a brush pen.

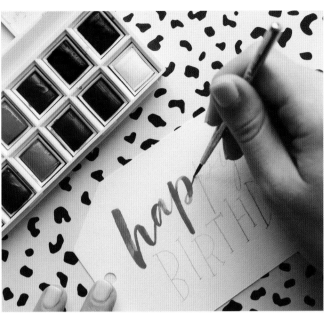

8 And to achieve thin upstrokes or connecting strokes, use only the thinnest tip of your paintbrush. You can see how the watercolor is both thinner and sometimes lighter in color on these kinds of strokes.

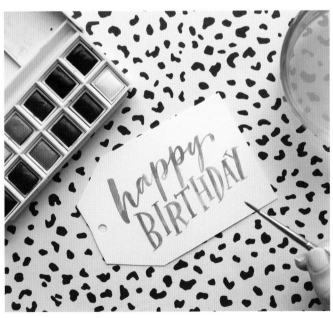

9 Keep lettering until you've finished the tag, then set it aside to dry completely.

10 A simple variation of this tag is to alternate colors when lettering. You can do this with both script and serif writing.

11 To get really artsy, the next style will require a wider, flat-tip paintbrush like this one.

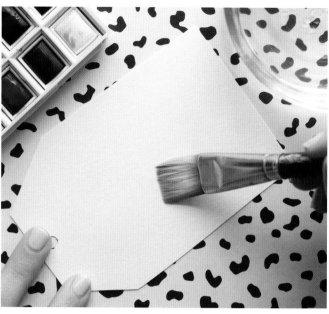

12 Brush some clean water onto the bottom half of your tag.

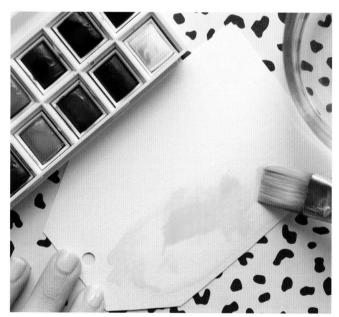

13 Dot some color into the wet areas you created and watch the pigment spread.

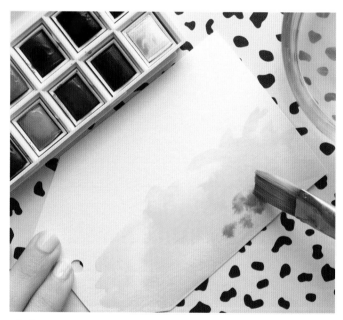

14 Add another shade similar to your first color to the mixture. Add as much color as you need to achieve your desired look.

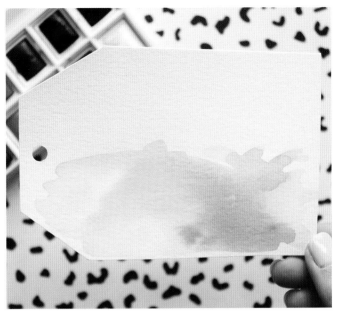

15 Set this aside to dry completely or use a hairdryer or heat tool to speed up the process.

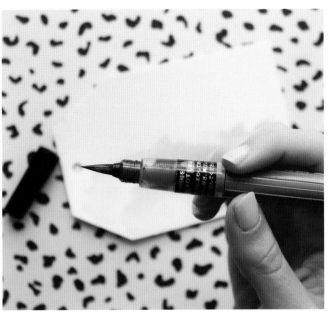

16 This ink brush is going to add funky lettering on top of the watercolor wash tag. Use whatever brush and style of lettering you prefer.

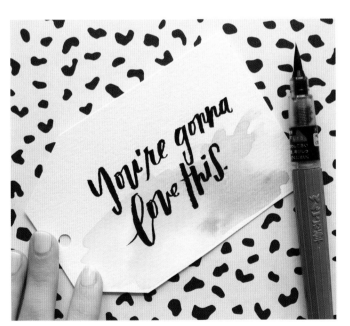

17 Add a phrase to finish this tag.

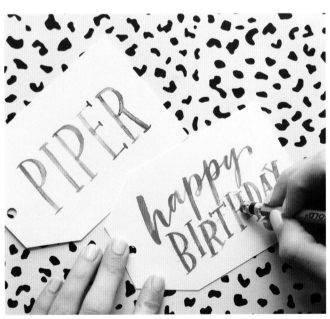

18 When the tags are completely dry, gently erase any stray pencil marks. Add string, and your tags are ready for use.

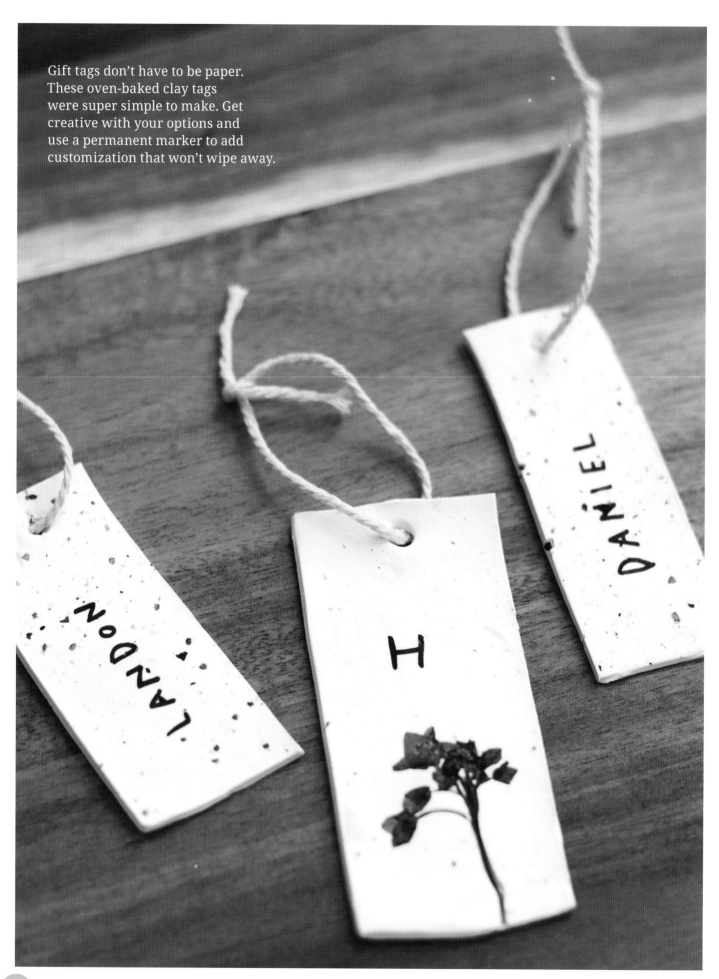

Gift tags don't have to be paper.
These oven-baked clay tags
were super simple to make. Get
creative with your options and
use a permanent marker to add
customization that won't wipe away.

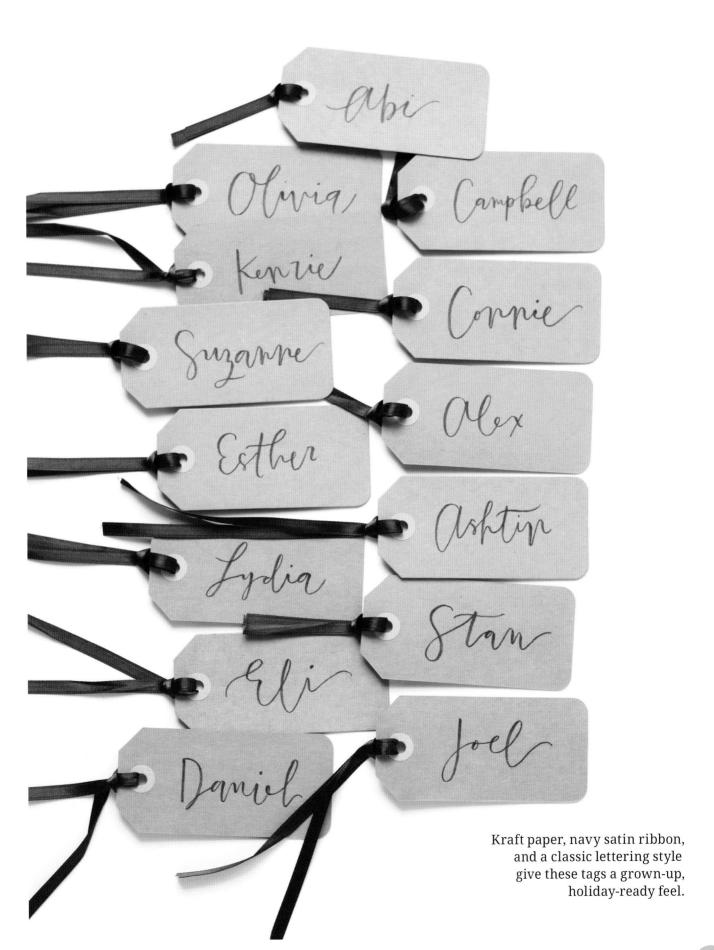

Kraft paper, navy satin ribbon,
and a classic lettering style
give these tags a grown-up,
holiday-ready feel.

Wrapping Paper

Take gift wrap to another level by adding some lettering to it. Custom wrapping paper will make the gift inside that much more special to the lucky recipient!

MATERIALS
- Large roll of white paper
- Scissors
- Tape or paperweights
- Paint pen
- Decorative string and gift tag

1 Find a roll of plain, matte wrapping paper at your local craft store. I prefer to use matte white paper because it is the most versatile. Paper with a glossy finish might be challenging to work with.

2 It is easiest to work with precut pieces of gift wrap. Determine the size you'll need for the gift you're giving, cut it out, and lay it out on a large work surface, using a low-tack tape or paperweights to hold down the corners.

3 I'm using a paint pen for this project, but you can make your paper special with the tool of your choice. Choose a color or style that suits the person receiving the gift—this is such an easy way to add meaningful touches.

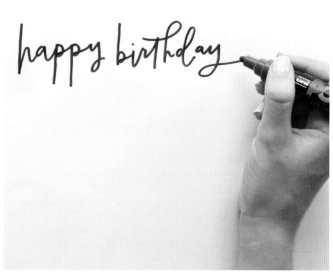

4 I'm going with a simple, messy, monoline style for this birthday gift wrap. This will be an all-over pattern, meaning that it will cover the entire precut sheet of paper. I chose a place to start and didn't even worry about sketching—I wanted this paper to have a handmade feel.

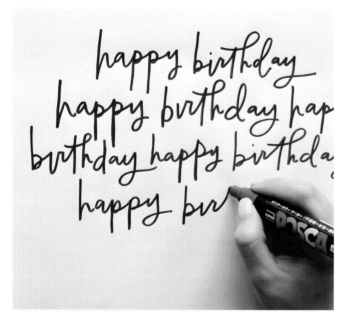

5 Repeat your phrase, staying consistent with size and style throughout. You don't have to choose just a phrase, either. Song lyrics, inspirational quotes, or personal anecdotes work for this type of custom project as well.

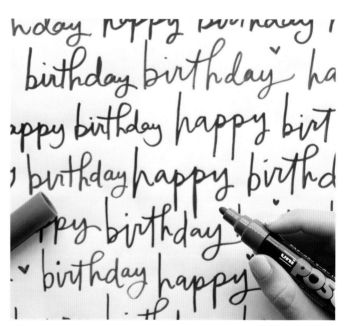

6 The simplicity and handmade look of this gift wrap will be stunning as we put the finishing touches on it. Here, I added a few tiny hearts mixed in with the lettering.

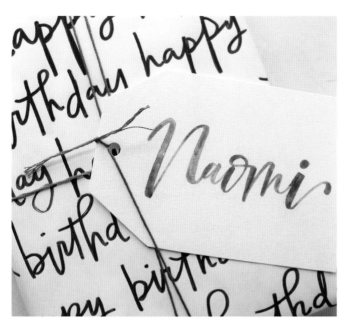

7 Wrap your gift and pick out coordinating string to tie around the present. Finish it off with a handmade watercolor gift tag (see page 84).

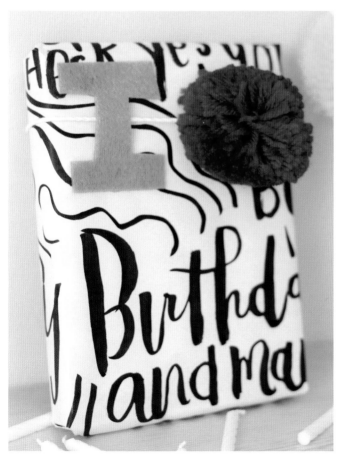

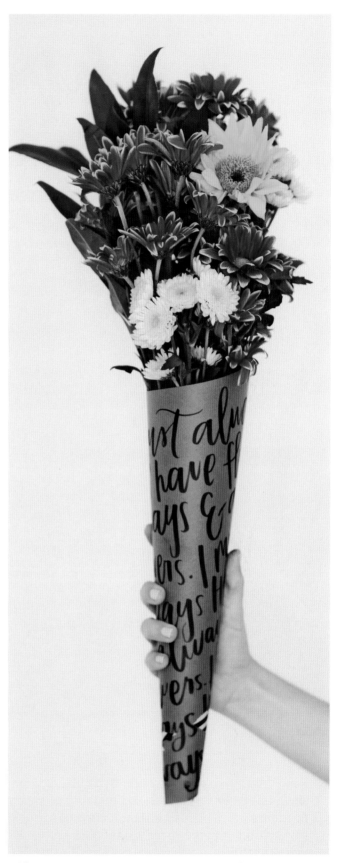

For the fun, funky person in your life, try a chunkier lettering style with more variation in size. Finish it off with a colorful pom-pom and a felt initial to serve as the gift tag.

Gift wrap goes on everything—even flowers! Pick up a sheet of kraft paper from the store and deck it out with a sweet sentiment to make your bouquet even better.

Envelopes
& CARDS

There's nothing quite like receiving a handmade card and perfectly addressed envelope in the mail! Give your snail mail a glam makeover with this easy project.

MATERIALS
- Cards and envelopes
- Pencil
- Eraser
- Metallic pens

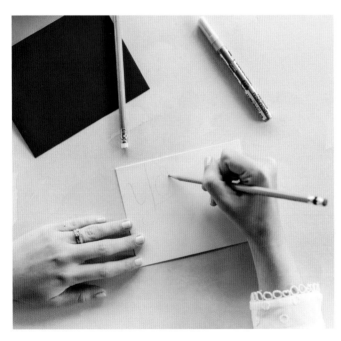

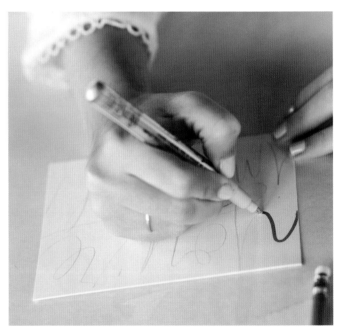

1 First, you get to choose your cards and envelopes! I loved this navy color, but I chose to make my own note card by cutting cardstock and folding it to the correct size for the envelope. With a pencil, sketch your design on the front. This is an invitation, so I'm going with a simple "You're Invited" that will flood the entire front of the note card.

2 Use a metallic pen, a paint pen, or a brush pen to letter over your sketch, taking as much time as you need.

781 MAIN ST.
FLORENCE, IOWA 89280

You're invited

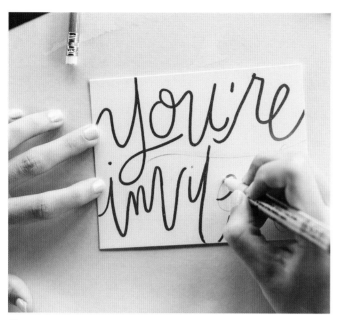

3 Keep it monoline as shown here...

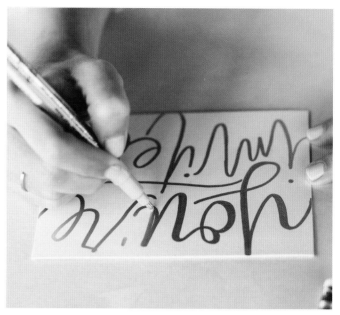

4 ...or thicken your downstrokes for a calligraphy look.

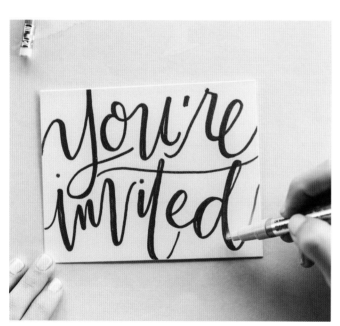

5 Touch up any missed areas, and you're ready to move on to the envelope.

6 I'm using my favorite white pastel chalk pencil to write on this dark navy envelope. If you are using a lighter-colored envelope, you can use a regular pencil.

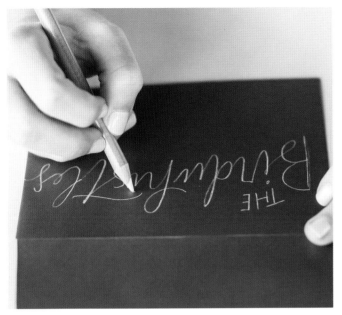

7 I want the address to cover the entire front of the envelope much like the lettering covers all of the note card. There is nothing traditional about this invitation! Just make sure if you plan to mail the envelope that nothing important will get covered by a stamp.

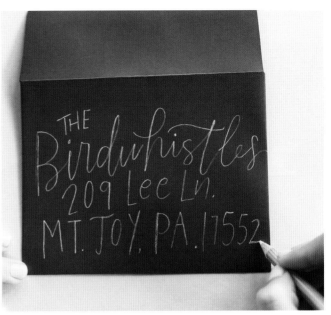

8 Don't fuss over planning where everything will go—let it flow, let it be fun and organic. I promise this will wow the recipient no matter what.

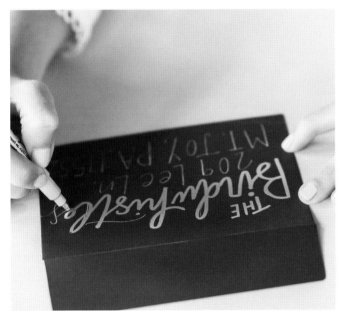

9 Go over your sketch with the tool of your choice. Metallics look stunning on these jewel-colored envelopes.

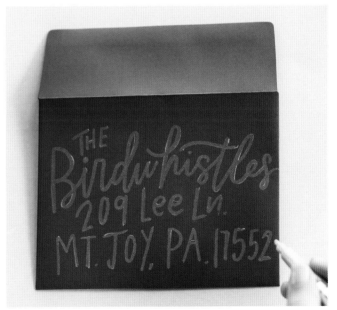

10 After you've completed your lettering, give the ink adequate time to dry and then gently erase any remaining pencil marks.

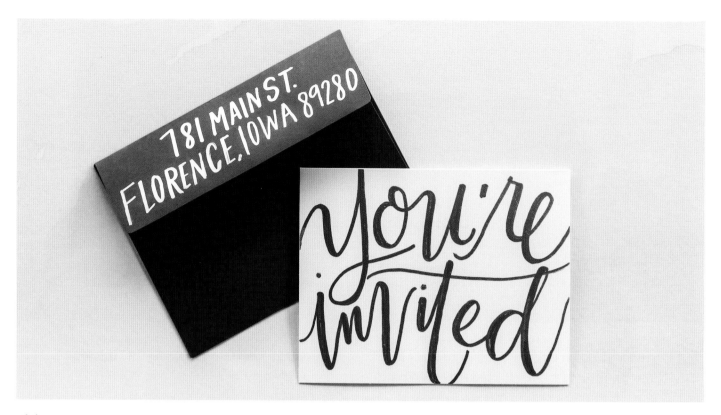

11 Add the return address on the back flap, giving it its own space to be a funky touch on this invitation.

TIP:
If you need extra help with straight lines, there are many envelope-addressing templates on the market. Choose one that is right for you!

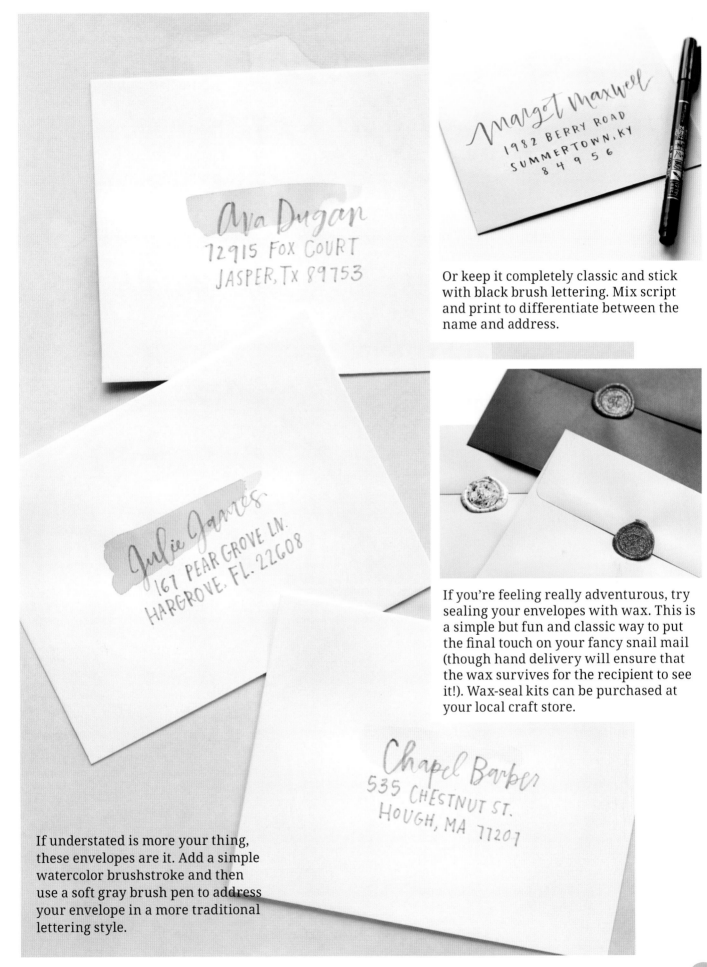

Ava Dugan
72915 FOX COURT
JASPER, TX 89753

Margot Maxwell
1982 BERRY ROAD
SUMMERTOWN, KY
84956

Or keep it completely classic and stick with black brush lettering. Mix script and print to differentiate between the name and address.

Julie James
167 PEAR GROVE LN.
HARGROVE, FL. 22608

If you're feeling really adventurous, try sealing your envelopes with wax. This is a simple but fun and classic way to put the final touch on your fancy snail mail (though hand delivery will ensure that the wax survives for the recipient to see it!). Wax-seal kits can be purchased at your local craft store.

Chapel Barber
535 CHESTNUT ST.
HOUGH, MA 77207

If understated is more your thing, these envelopes are it. Add a simple watercolor brushstroke and then use a soft gray brush pen to address your envelope in a more traditional lettering style.

HAND-LETTERED
Globe

You might be shocked at how simple it is to add hand lettering to a globe! Once you learn the process for this impressive project, you'll be making globes for everyone you know.

MATERIALS

- Globe
- Multisurface craft paint
- Paintbrush
- Paper
- Pencil
- Eraser
- Scissors
- Tape
- Metallic paint pen
- Measuring tape

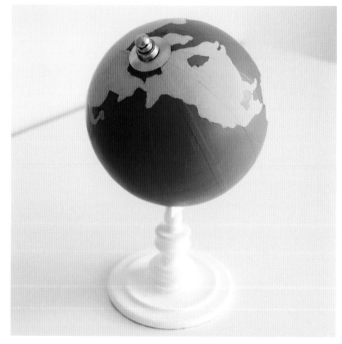

1 Start with a globe—painted or not! I painted my globe these fun colors using multisurface craft paint. Get creative with color schemes or even use chalkboard paint to create a chalkboard globe.

2 Giving a globe like this a nice, even coat of paint is actually the hardest part of the project! Be careful with the continents' edges.

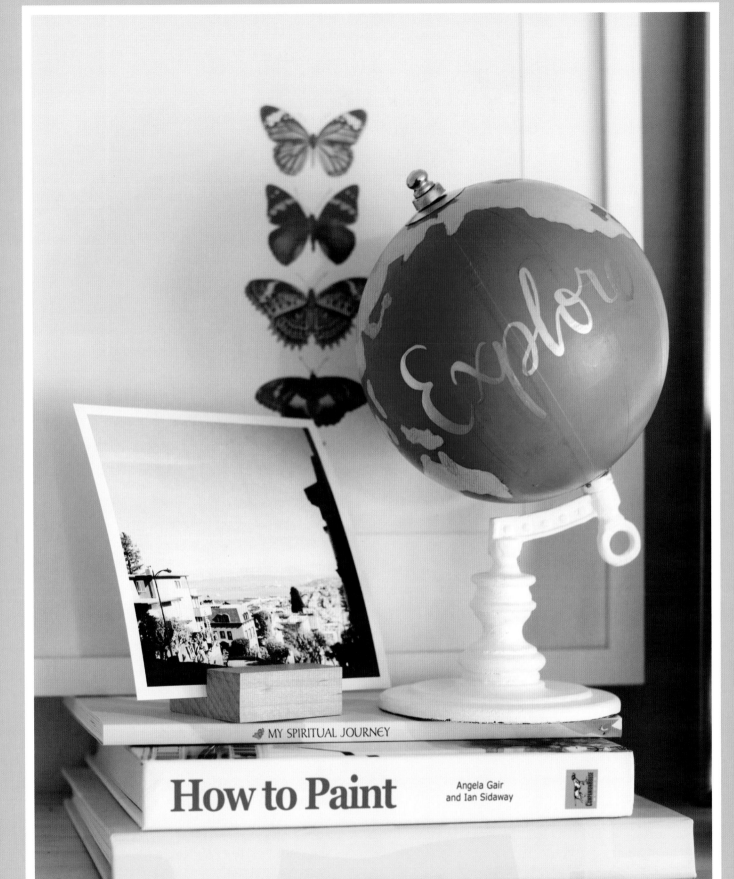

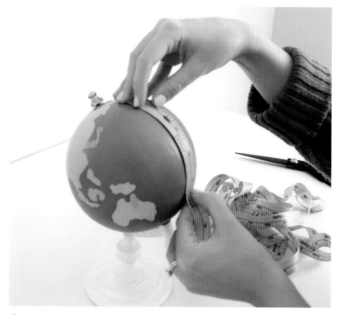

3　Use a measuring tape to determine the size of the area where your lettering will go.

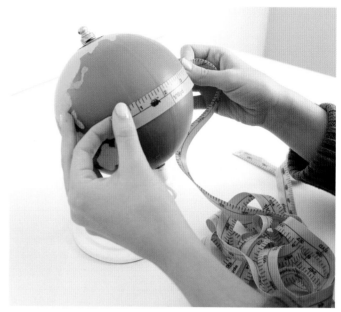

4　Make sure you get a measurement of the entire space, both height and width. You do not have to measure, but it helps take some of the guesswork out of the designing process.

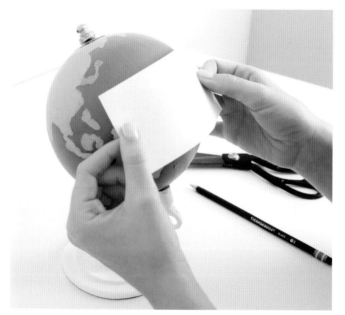

5　Trim a piece of paper to roughly the same size you want your design to be. Make sure the sizing is a good fit before moving on to the next step.

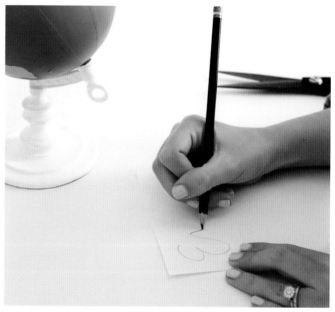

6　With a pencil, roughly sketch out your design on the paper. This doesn't have to be perfect! I am going with a simple "Explore" because of the smaller size of my globe. However, if you prefer a longer phrase or quote, this process works for that as well.

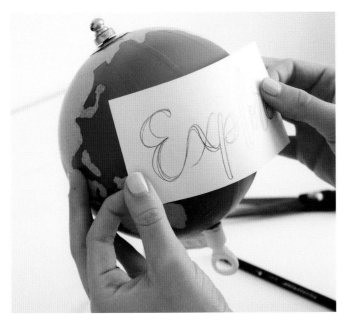

7 Continue checking the size of your design throughout the different steps in this process.

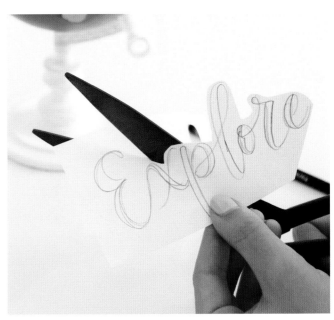

8 To transfer guidelines to the globe, cut closely around the outline of your design. This doesn't have to be completely accurate—as always, the guide is a loose reference.

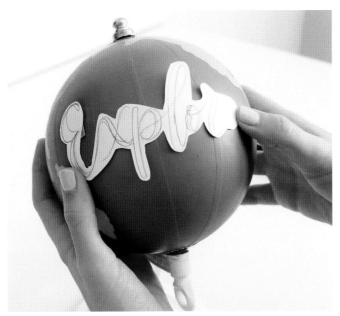

9 Adhere the outline to the globe with a low-tack tape or removable adhesive.

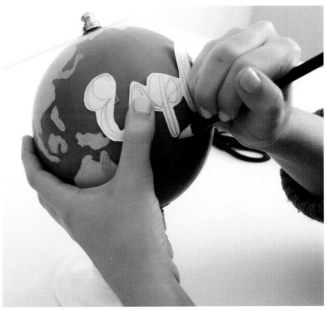

10 With a pencil, lightly sketch around the paper template. You can sketch all the way around it, or just in certain areas to serve as guide marks for your lettering. This should be light enough so that you can barely see it, which means it will be easier to erase at the end.

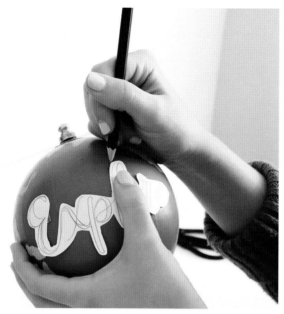

11 Make sure your template is pressed nice and flat as you trace. You may want to add little scissor cuts to the edges of it to help it lie flat.

12 I am using a metallic gold paint pen for my lettering, but you can use paint and a paintbrush or an acrylic paint pen. The tools you use are up to you and what fits with your color scheme.

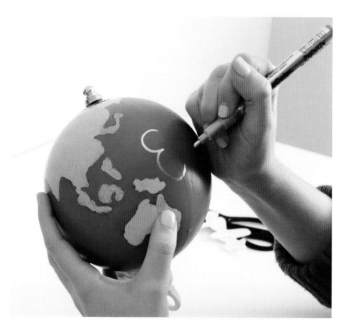

13 Begin tracing over your pencil outline.

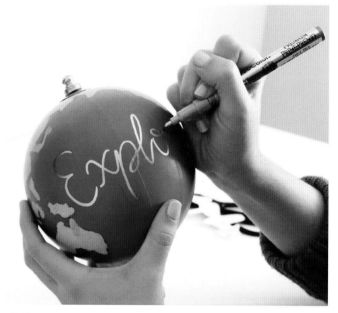

14 Take your time. No one crosses an ocean in just a minute!

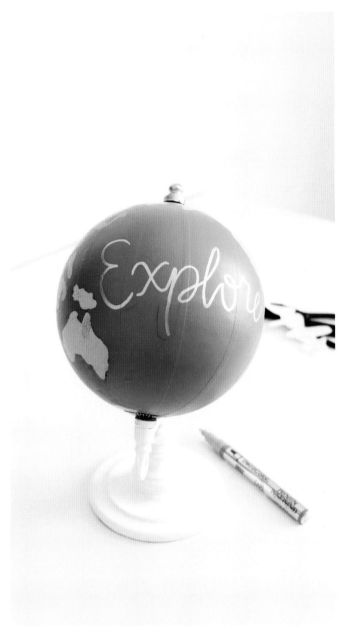

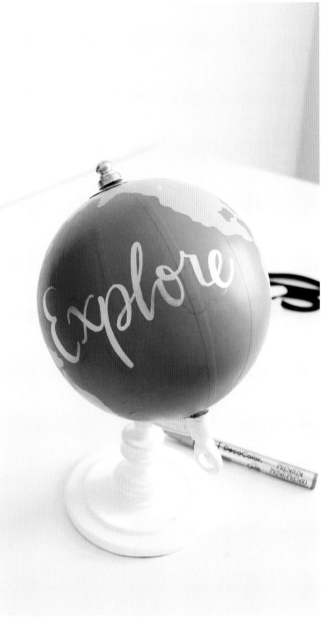

15 When you're done with your initial tracing, you can leave the design monoline as is.

16 Or you can thicken your downstrokes and call it a day!

TIP:
Do different lettered designs on opposite sides of the globe so that you can simply rotate the globe to change up your décor whenever you feel like it!

Globes don't have to be 3D! This flat wood piece makes the most beautiful addition to a home office or library. I used paint and a small paintbrush for this design. Add some embellishments, like butterflies, to make it even more unique.

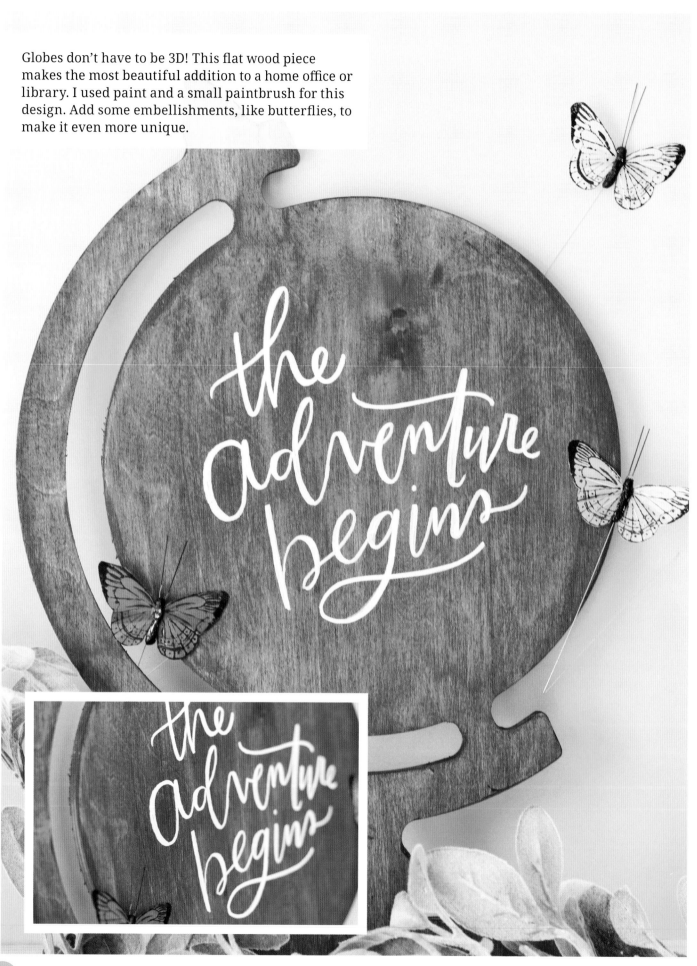

This large globe was beautiful as it was, but the pink and safari green color scheme I used to paint over the continents and oceans made it even better. I chose to add continent and ocean names with a gold paint pen to finish it.

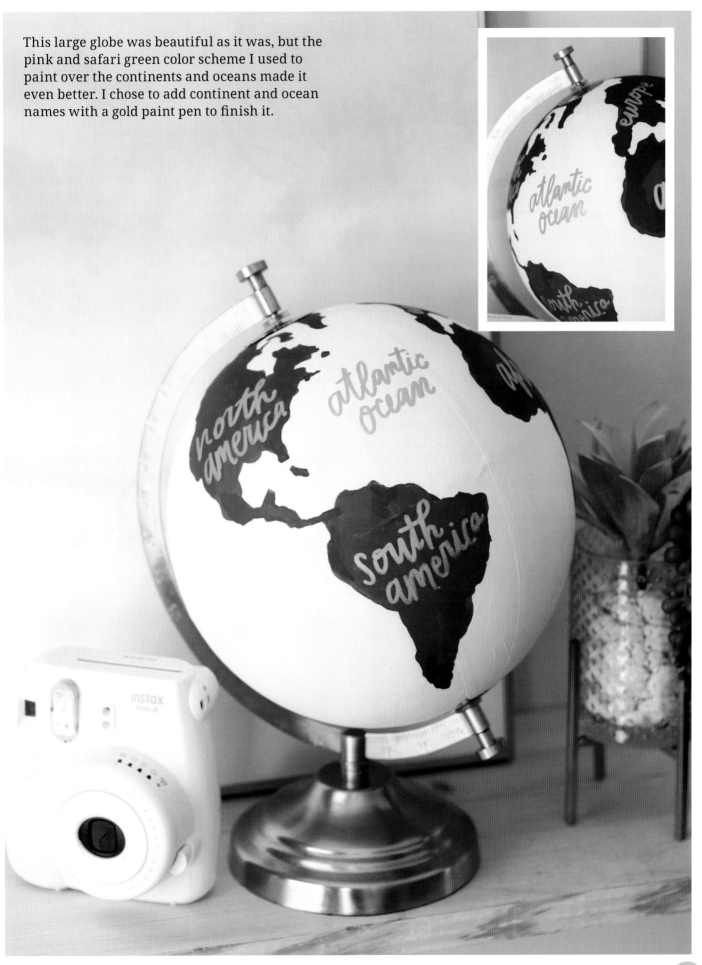

HAND-LETTERED
Display

One of my favorite uses of brush lettering is to document and display special quotes and memories around my home. See how easy it is to do with this project.

MATERIALS
- Wire photo display or similar item
- Heavyweight cardstock
- Scissors
- Pencil
- Eraser
- Brush pen
- Clothespins

1 For a project this simple, you only need a few things. I am using this unique wire photo display, but you can use anything similar that fits your style. Cut your cardstock down to a size that works for your display.

2 With a pencil, lightly sketch out your quotes in whatever style suits you.

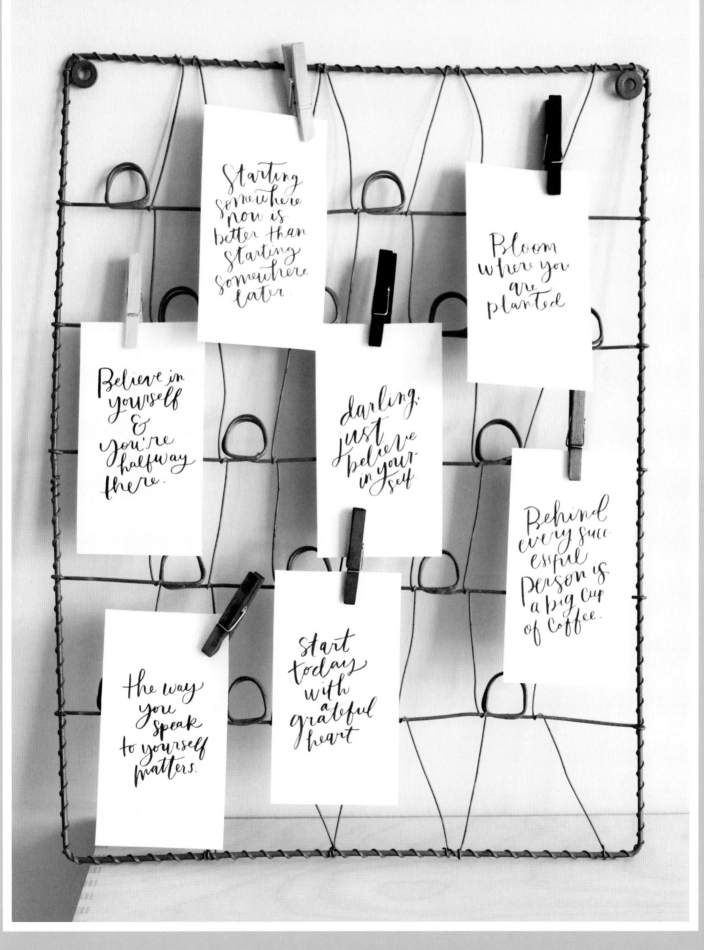

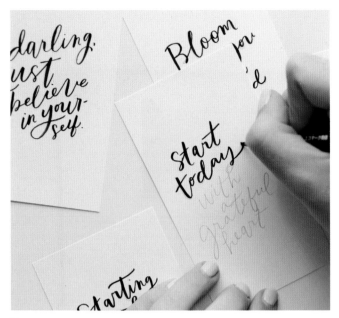

3 I used a small brush pen for a modern, imperfect lettering style. Trace over your pencil sketches with your lettering tool of choice.

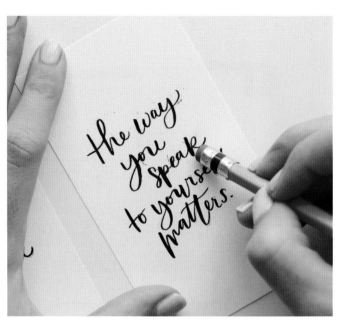

4 Gently erase any stray pencil marks.

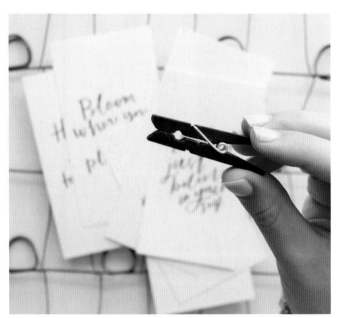

5 Choose clothespins that suit your decorating style. I went with black to match my wire frame but later ended up mixing in some neutral browns as well.

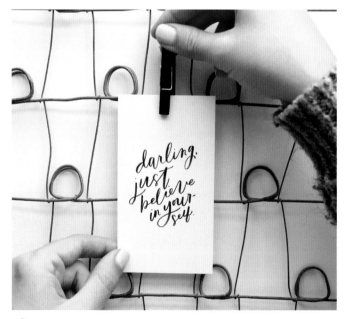

6 Attach your quote cards to your display using your clothespins. Change up your cards and give them away whenever you want—you can always make new ones!

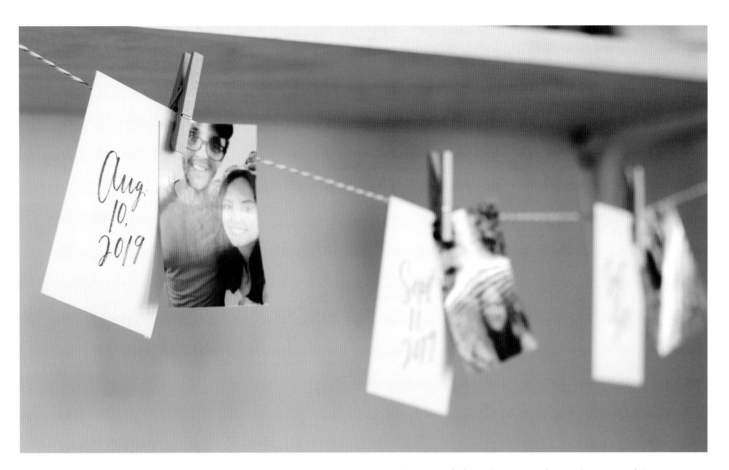

Think of creative ways to document memories and moments in your life using your lettering. Combine your lettering with photos and twine, and you've got a banner that is more than just decorative.

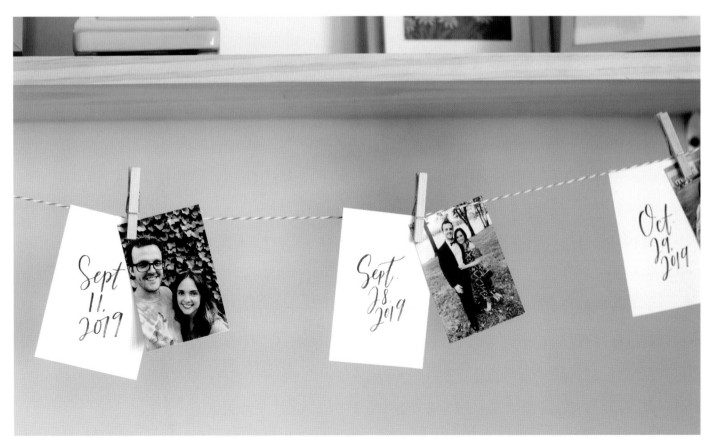

Denim Jacket

Painting on fabric is my favorite way to customize functional items in my wardrobe and in my home. You'll need a few specific supplies, but they are easy to find and inexpensive.

MATERIALS

- Denim jacket
- Paper
- Pencil
- Eraser
- Temporary/disappearing/ washable fabric marker
- Fabric paint
- Paintbrushes
- Iron or other heat-setting tools (depending on products used)
- Patches (optional)

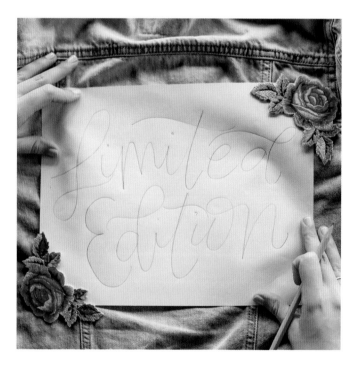

1 Take a look at the area you'll be lettering and decide how much of the area you'd like your design to cover. I laid a piece of standard printer paper, as well as the embellishments I planned to add to the jacket at the end, on the back of my denim jacket.

2 With your paper still in place, use a pencil to lightly sketch out your design. This doesn't have to be perfect, as you're only completing this step to use as a loose template to get a feel for the size and shape of the design.

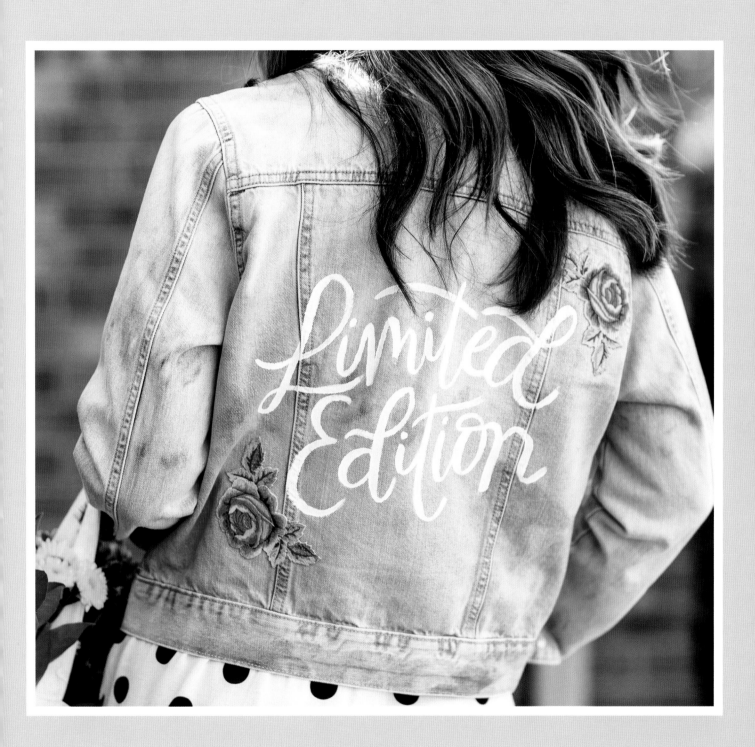

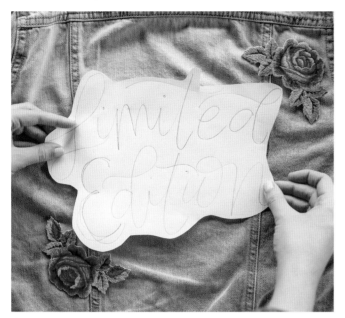

3 If you want a more specific template, cut your design out, leaving a little bit of a border along the perimeter.

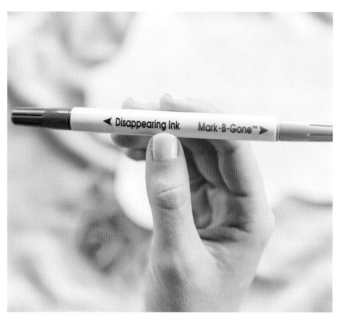

4 Lettering on fabric is so easy with a fabric pen. This one has two sides: disappearing ink (which fades away over time) and an ink that disappears when wiped with a damp cloth. I prefer to use the disappearing-ink side as long as I know I can complete my project before the ink fades completely. For this pen, I have about twelve to twenty-four hours.

5 Place your rough template on the back of your jacket and use your disappearing-ink fabric pen to trace around it. I chose to only partially trace around my template, but you can trace the entire outline if you need to.

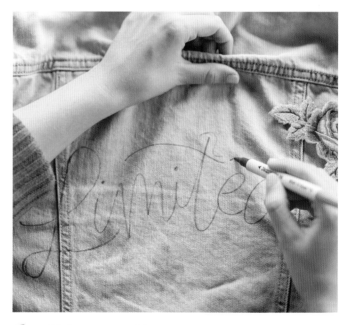

6 Within your outlined template on the jacket, fill in the lettering. The outline of the template should give you a reference of where and how large to place your lettering. Remember that you can sketch your lettering as many times as it takes to get it right—the ink isn't permanent!

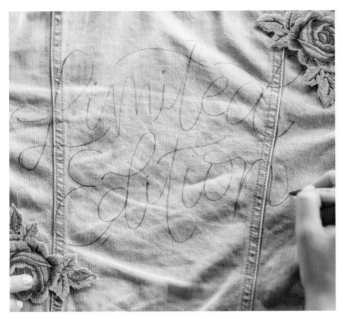

7 This is my final sketch. I am not going to thicken the downstrokes until the painting steps.

8 I used a multisurface paint for my jacket. Use any fabric or multisurface paint that provides instructions for fabric. You want your work to last!

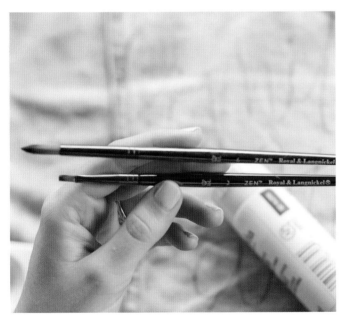

9 These two brushes will help me achieve my desired effect. The large round-tip brush will help in getting a calligraphy look, and the smaller brush will help with creating clean edges and filling in smaller areas.

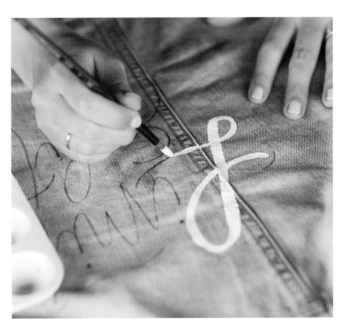

10 It's time to begin painting over your design. Use the larger brush.

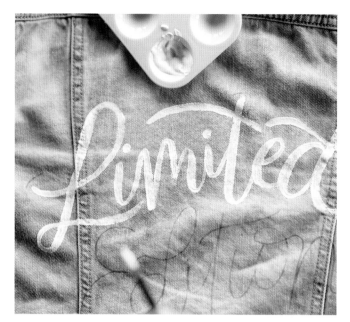

11 Take your time with this step. Don't worry about the paint being completely opaque. Your design will most likely need two coats of paint to achieve opacity.

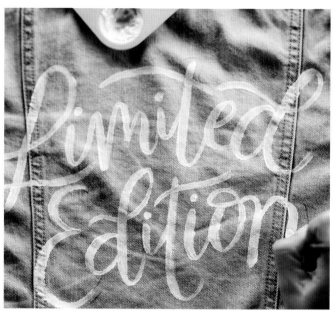

12 My first coat is complete. That was so simple!

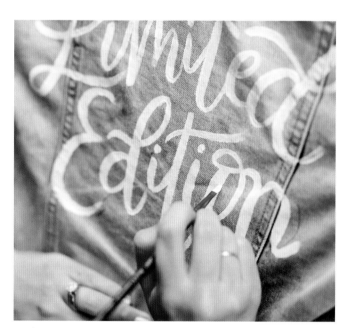

13 Use the smaller brush to go over your strokes with a second coat of paint, cleaning up any rough edges or areas that need some extra attention.

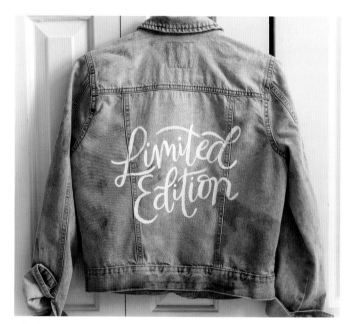

14 When you're finished, allow the paint to dry overnight. When dried, complete the process of heat-setting your paint into the fabric according to the manufacturer's instructions. For the paint I used, I laid a cotton cloth on top of my design and gently ironed over the cloth on the cotton setting.

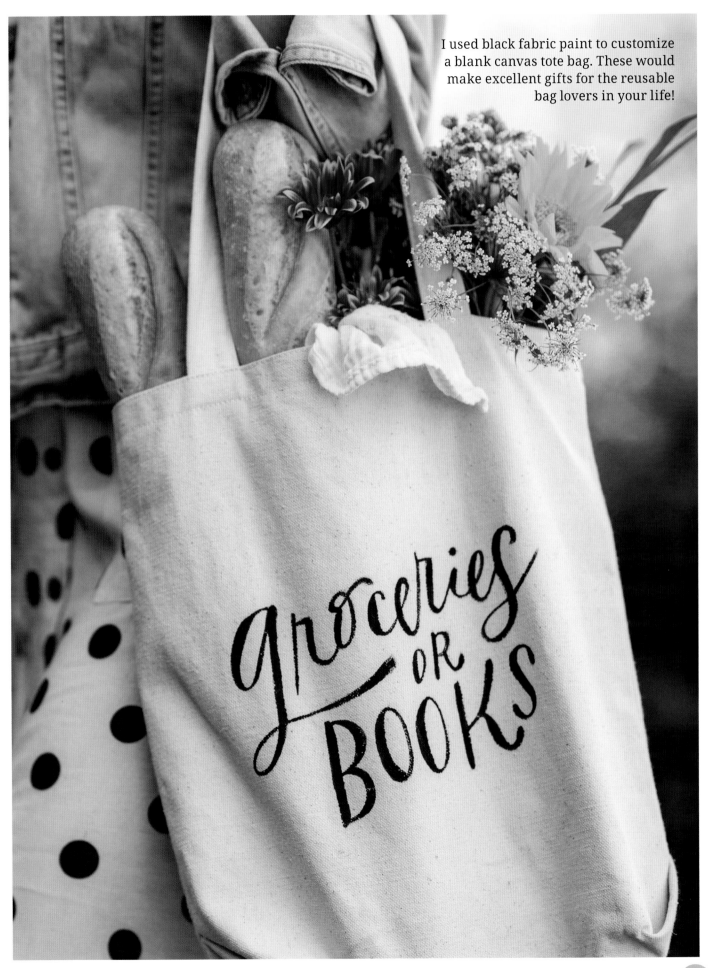

I used black fabric paint to customize a blank canvas tote bag. These would make excellent gifts for the reusable bag lovers in your life!

groceries
OR
BOOKS

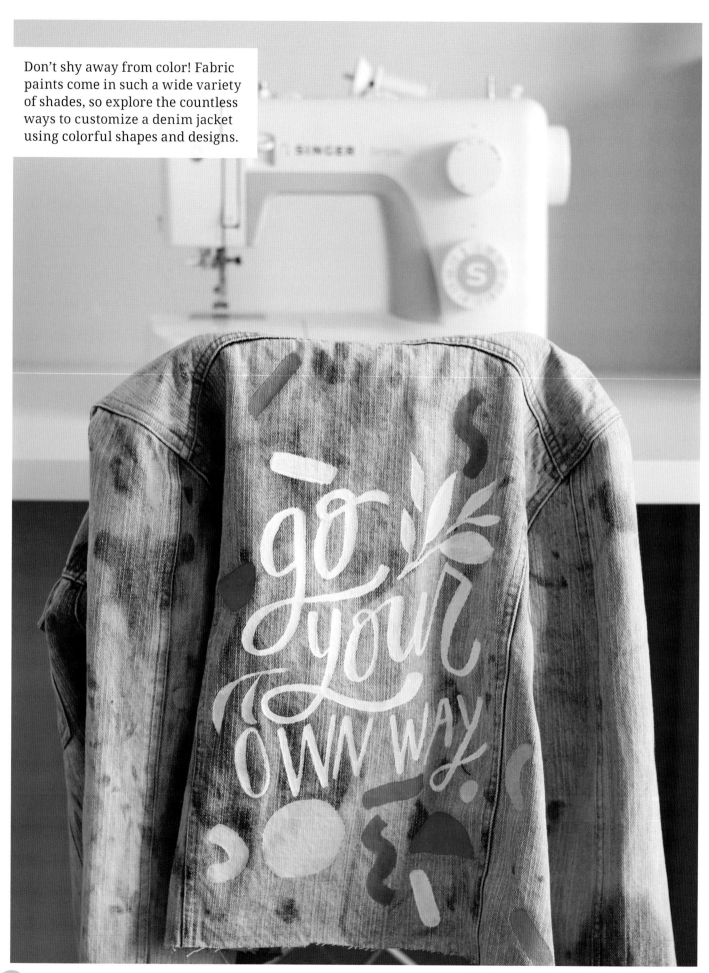

Don't shy away from color! Fabric paints come in such a wide variety of shades, so explore the countless ways to customize a denim jacket using colorful shapes and designs.

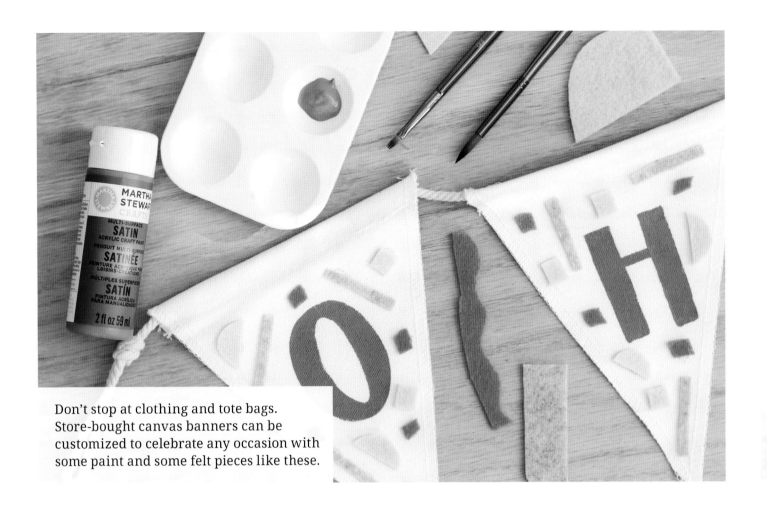

Don't stop at clothing and tote bags. Store-bought canvas banners can be customized to celebrate any occasion with some paint and some felt pieces like these.

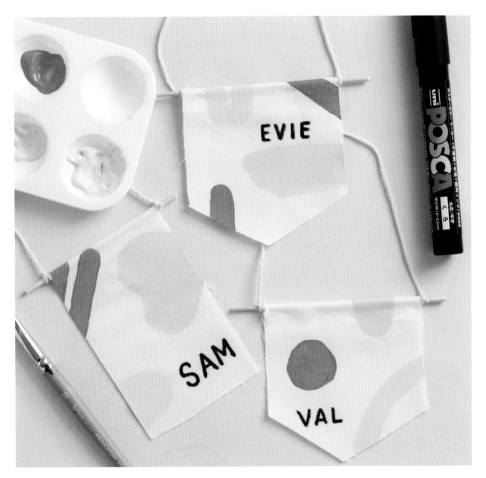

Perfect for a set of friends in your life, these mini canvas banners are so simple to create with some fabric glue and cake pop sticks.

Templates

inspiration exists but it has to find you working

cake toppers

CUT OUT THESE TEMPLATES
AND USE THEM TO CREATE
YOUR OWN PAPER PIECES

ADHERE TOPPER
STICKS HERE

ADD SHADING
TO GIVE
DIMENSION!

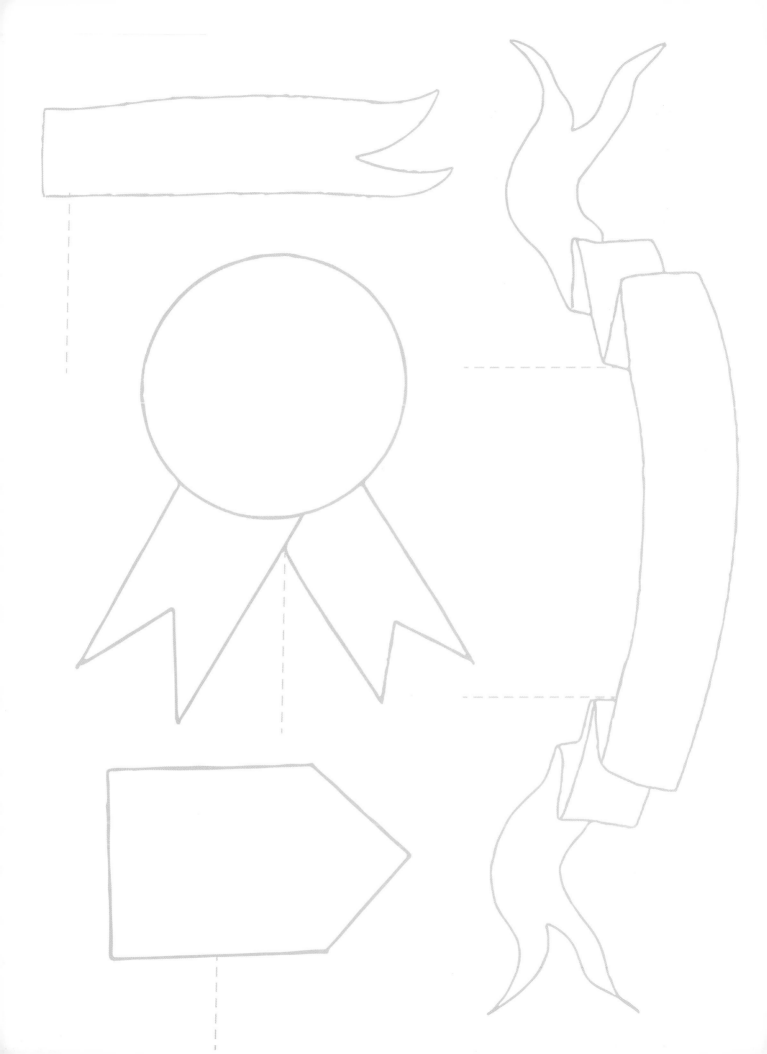

place cards & gift tags

FOLD HERE

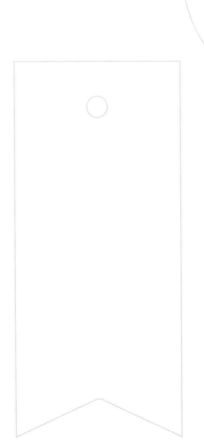

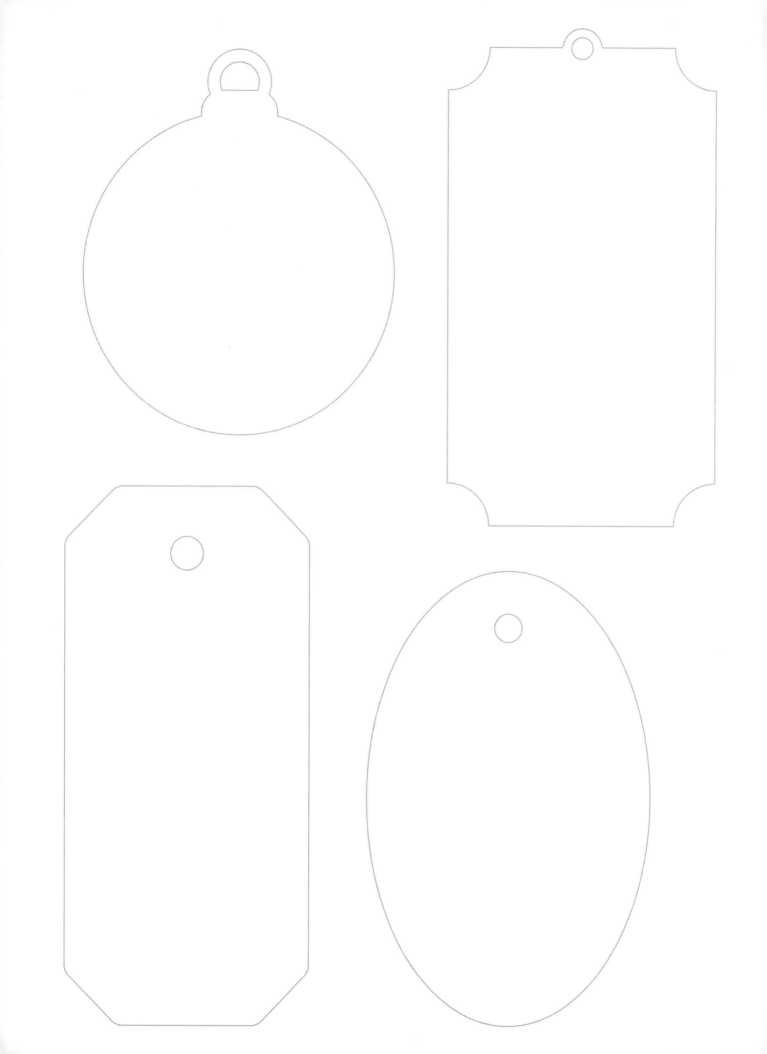

Index

Note: Page numbers in *italics* indicate projects and (templates).